Historic England

Plymouth

Ernie Hoblyn

AMBERLEY

First published 2018

Amberley Publishing
The Hill, Stroud, Gloucestershire, GL5 4EP
www.amberley-books.com

Copyright © Ernie Hoblyn, 2018

The right of Ernie Hoblyn to be identified as the Author
of this work has been asserted in accordance with the
Copyright, Designs and Patents Act 1988.

ISBN 978 1 4456 8330 0 (print)
ISBN 978 1 4456 8331 7 (ebook)

British Library Cataloguing in Publication Data.
A catalogue record for this book is available from the
British Library.

Origination by Amberley Publishing.
Printed in Great Britain.

Contents

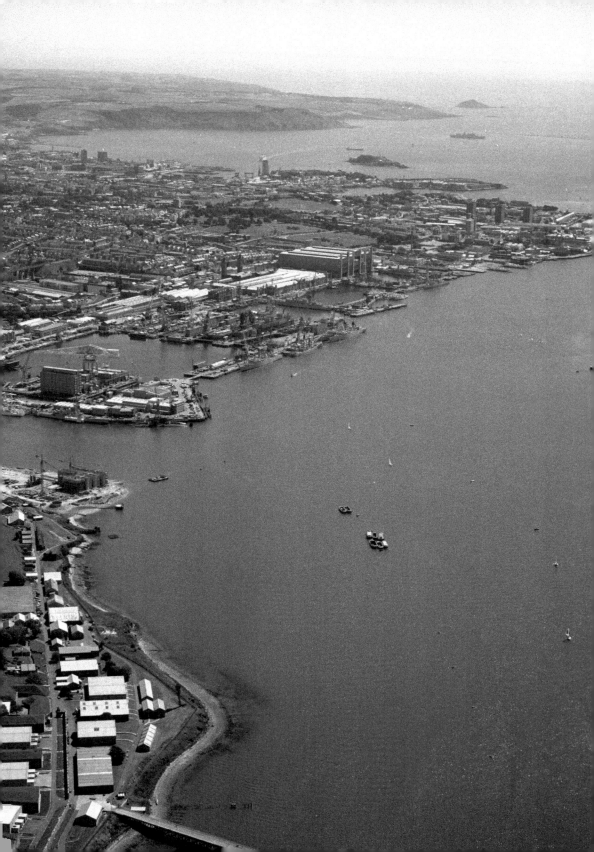

Acknowledgements

I am very grateful to three major sources of information used during my research: firstly I would like to thank Chris Robinson for his series of books about the history of Plymouth, which are always useful and informative; secondly I would like to thank Brian Moseley for his Old Plymouth and Old Devonport websites, which have provided me with answers to questions about some of the more obscure parts of the area; and thirdly I would like to thank the Devonport Naval Heritage Centre, in particular David Boden, for all their help and information about the Dockyard and Royal William Yard, providing me with answers that I have not been able to find anywhere else.

Apart from these major sources a few individuals have been enormously helpful including Graham Naylor and my old friends John and Janet Stitson. Without your help my job would have been much more difficult – thank you all.

Introduction

There has been a settlement in the area now known as Plymouth since the Iron Age, and by Saxon times what we now call Sutton Harbour was a fishing village. As early as 1254 it was granted a royal charter recognising its town status and of course it became very well known during the sixteenth century for its part in the fight against the Spanish Armada and during the seventeenth century for the departure of the Pilgrim Fathers.

Plymouth thus has a very long history, much of it intertwined with the military. It has been a military town for 300 years, catering for both the Navy with the dockyard, the Army with the Citadel (built during the seventeenth century) and finally for the Royal Marines with Stonehouse Barracks (built during the eighteenth century). Sadly, political pressures might bring an end to all of these in the near future.

Its military role has made it a prime target for the country's enemies at times and during the 1860s a ring of fortifications was built to protect the city from an attack that, thankfully, never came. The city was not so lucky during the Second World War, however, and in places – especially the city centre – it was bombed severely from 1941. Looking at the history of Plymouth we therefore have to look at 'historic Plymouth before the Blitz' and 'modern Plymouth after the Blitz' – two very different towns.

The old Plymouth, had it survived, would have been a nightmare for modern dwellers, particularly car owners. The higgledy-piggledy layout of the narrow streets in the city centre were blocked by traffic even before the Blitz; think how awful they would be today.

Sadly, along with the jumble of narrow streets we also lost some lovely old buildings, although the Barbican, the most historic part of Plymouth, was largely undamaged and much still remains. Luckily the Historic England archive contains some pictures of the old Plymouth as well as pictures of the new. It also shows some of the bomb damage, empty shells of bombed-out buildings and the often small temporary homes of some of the major stores whose premises had been flattened or burned out.

I have added a few pictures showing Plymouth as it is today – a huge, sprawling city that now includes vast areas that were previously farmland during the war or villages outside the city limits.

Military Buildings

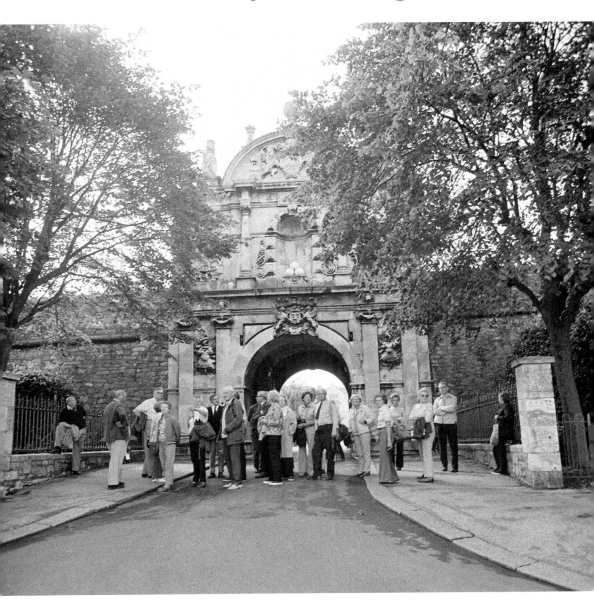

Main Entrance to the Royal Citadel, 1973
Built in the 1660s on the orders of Charles II to protect Plymouth during the Anglo-Dutch Wars, the Citadel incorporated an earlier fort known as Drake's Fort. As the city had been an indomitable supporter of Parliament during the Civil War, many Plymothians wondered if some of the landward-facing cannons were there to keep them under control rather than to protect them. (© Historic England Archive)

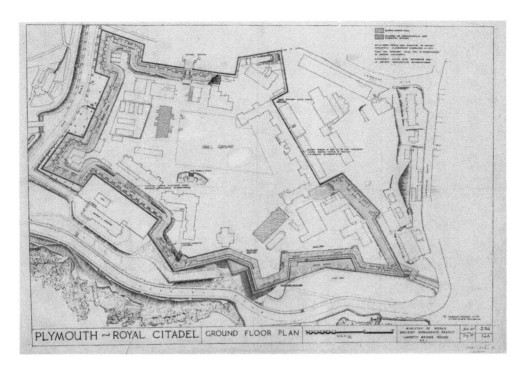

PLYMOUTH ~ ROYAL CITADEL | GROUND FLOOR PLAN

Above: Plan of the Royal Citadel in the 1920s

As well as the general layout of the Citadel, this plan shows the south-eastern extension wall, which ran from the Citadel down to Fisher's Nose. Until its demolition in 1933 this wall restricted access from the Barbican to the Hoe, with pedestrians only allowed access through what was known as the 'Cage Walk' when it was open. The wall's demolition allowed the construction of Madeira Road and its junction with Commercial Road. (Historic England Archive)

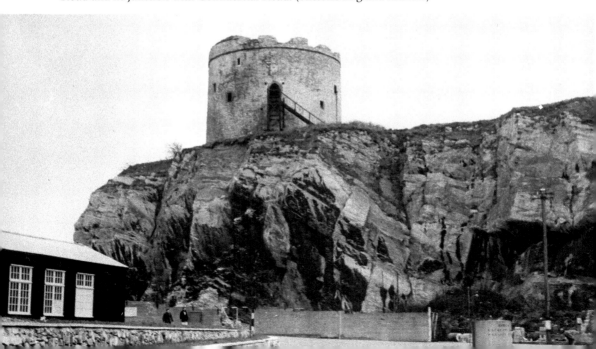

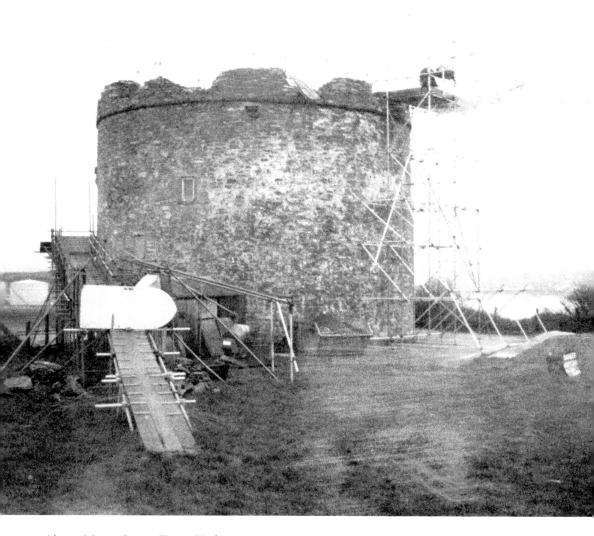

Above: Mount Batten Tower Undergoing Restoration Between 1950 and 1975
The tower was named after William Batten, who commanded the Royalist forces besieging Plymouth and made great use of the earthwork battery of the time by firing its cannon towards the town and its Parliamentarian inhabitants. This showed how useful a battery of cannon could be in this position as it also afforded protection against incoming ships in the Sound. (Historic England Archive)

Opposite below: Mount Batten Tower, 1962
A view of the Commonwealth-era Mount Batten Tower taken from the road below. The tower replaced an earthwork occupied by Royalist forces besieging the Parliamentary city of Plymouth during the Civil War and during the reign of Charles II it helped to protect the Sound against possible Dutch attack. (Historic England Archive)

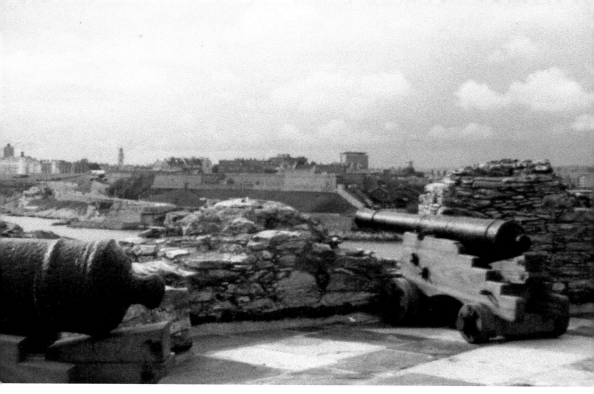

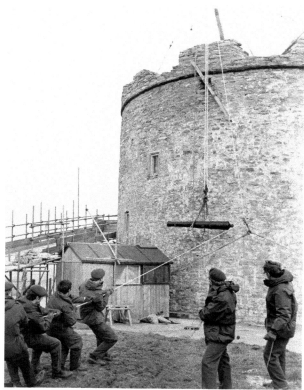

Above and left: Rearming the Tower, 1975

Following restoration work the tower was rearmed with cannons in 1975, although not with the ten cannons based there during the Civil War. The work was done by men of the RAF who were then based at RAF Mount Batten, the former Second World War seaplane base that lined the Cattewater to the north of the tower. (Historic England Archive)

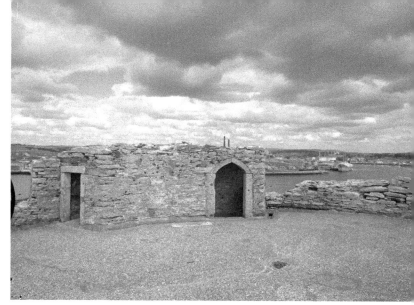

View from the Roof of Mount Batten Tower, 1970
Cattedown Wharves and the mouth of the River Plym can been seen in the background of this view from the top of the tower. Originally there were ten cannons on the roof, and during the Second World War two quick-firing guns, which were also installed on Drake's Island (see below), were placed here as part of the Plymouth defences. (© Historic England Archive)

Drake's Island, 1996
An 1866 rifled muzzle-loader cannon, one of a group that had been dumped on Drake's Island and rediscovered several years ago. It was mounted onto a replica iron mount and installed in one of the island's gun emplacements. The Drake's Island fortification was part of the so-called Palmerston Follies built to protect Plymouth from the French during the 1860s. During the Second World War it was garrisoned by 500 men with two 'twin-6' quick-firing guns to protect against fast German motor-torpedo boat attacks. (© Crown copyright. Historic England Archive)

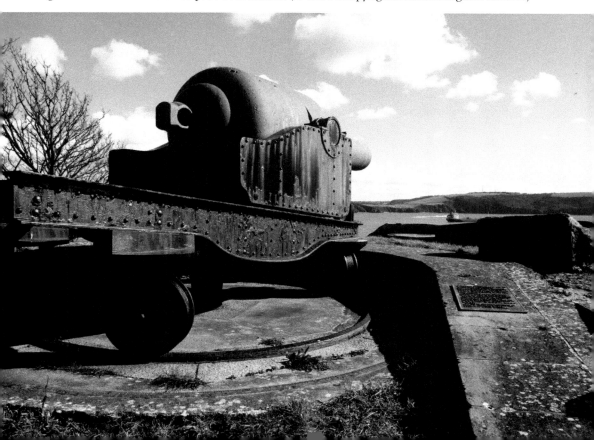

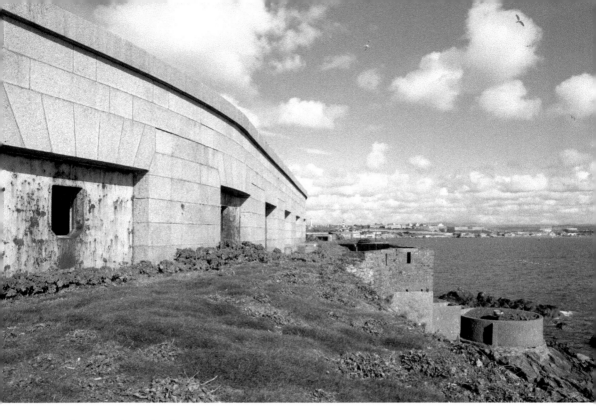

Above: Drake's Island Casemates, 1996
A view of the casemates taken in 1996. All the Palmerston Follies had casemated guns. This allowed the 9-inch rifled muzzle-loader guns, which had limited traversing mobility, to have a broad sweep of fire against any advancing enemy ship that might venture into the Sound. Firing in sequence they could cover the enemy all the way into the port. (© Crown copyright. Historic England Archive)

Below: Drake's Island Today
This view from Jennycliff shows the curving granite wall of the fortification and some of the casemates, visible as the rust-red armour plate squares set into the wall with a square hole cut for the cannon to fire through. In front is a defensive wall with slots to allow muskets to fire at any attackers. (Author's collection)

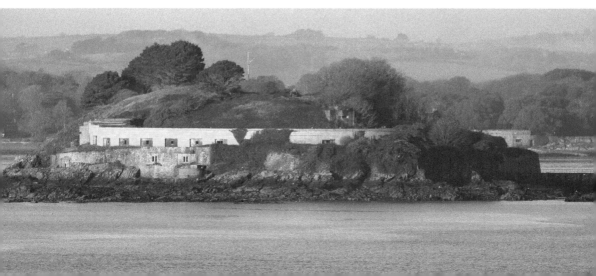

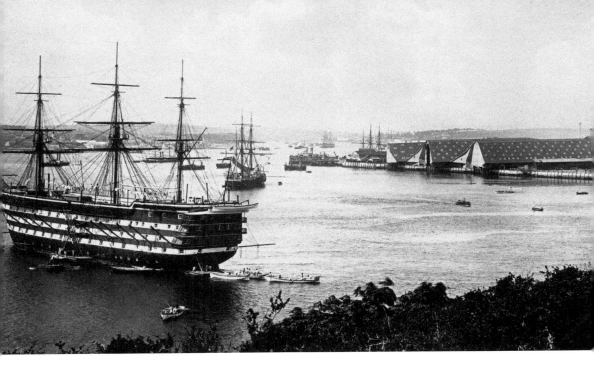

HM Naval Base Devonport (aka Devonport Dockyard), 1850–1920
A view of the covered slipways at South Yard taken from near Cremyll, showing HMS *Impregnable* moored in the foreground. These old ships were used as accommodation and for the training of sailors, and there were several that were all renamed HMS *Impregnable* after the original ship herself was scrapped. This picture is dated 1850–1920 but appears to show HMS *Howe*, which was *Impregnable* from 1888 to 1919. A picture taken by Francis Frith in 1904 shows the same ship. Later *Impregnable*s included outdated First World War cruisers including HMS *Powerful* and HMS *Andromeda*. (Historic England Archive)

The First Sight of the Dockyard, 1956
Known to all as King Billy, the statue of William IV, which stands between No. 1 covered slipway and Mutton Cove, represents the figurehead of a 120-gun first-rate of 1833 called the Royal William. King Billy is the first sight a returning ship gets of Devonport Dockyard and makes a great photo opportunity for any sightseers passing up the river. The statue on view today is actually a fibreglass replica and the precious original, fully restored, is now loaned to Plymouth City Museum. (Historic England Archive)

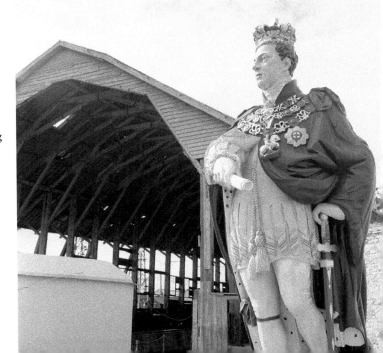

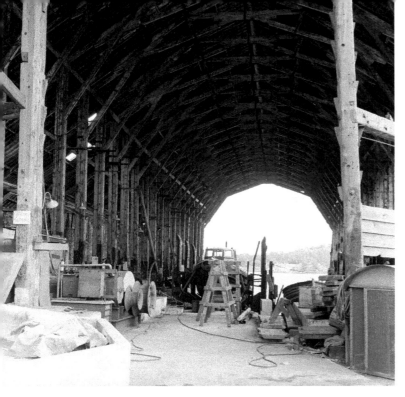

The Dockyard's No. 1 Covered Slipway, 1956
This is the last intact eighteenth-century building slip in any royal dockyard. According to a plaque it was constructed in 1763 and the timber structure supporting the roof – a magnificent piece of work – was added later, in 1814. It is now home to Stirling & Son Ltd, yacht repairers, whose lease, perhaps uniquely, states that only traditional wooden boatbuilding can be undertaken. (Historic England Archive)

Store S173 in South Yard with King's Hill and the Historic Gazebo in the Background, 2011
The gazebo commemorates George III's visit to the dockyard and has an inscription that reads, 'To perpetuate the recollection of the visit of His Majesty King George III of blessed and glorious memory, and of His Majesty's admiration of the rock on which it stands, and the scene around. This building was erected in the year 1822.' (© Historic England Archive)

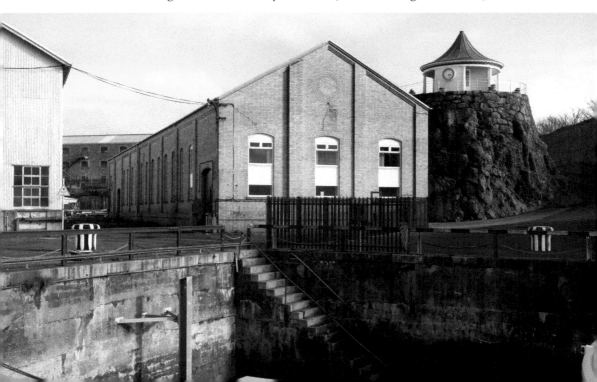

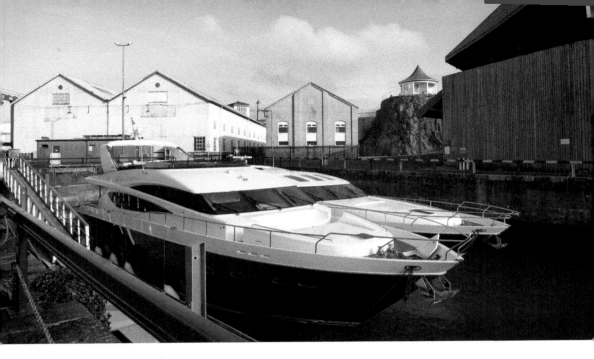

Above: The Slipway, Stores and Gazebo Showing Princess Yachts, 2011
This view across No. 4 slipway shows the end of the covered slipway, stores S172 and S173 with the gazebo and King's Hill in the background and some of Princess Yachts' products in the foreground. It shows that boatbuilding still continues here as it has for centuries, albeit on a smaller scale. (© Historic England Archive)

Below: South Yard, 2011
Part of the area of South Yard now used by Princess Yachts, the bow of one of which can be seen in the left of the picture. On the right is No. 1 covered slipway and also visible is King's Hill and the gazebo. (© Historic England Archive)

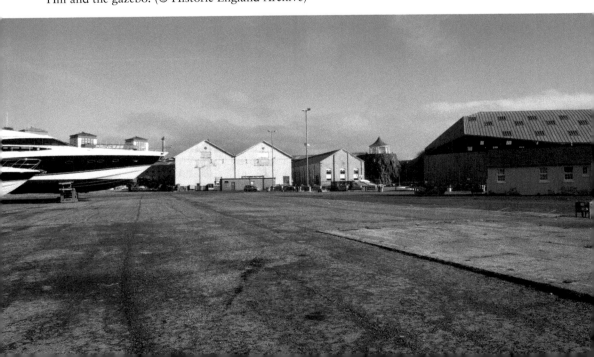

Above: No. 3 Slipway, South Yard, 2011

Constructed in the 1770s and for centuries used for repairing and building ships for the Royal Navy, this slipway is now used for launching the new Princess Yachts, some of which can be seen lined up on the left. The last warship to be launched from this slipway in Devonport was HMS *Scylla* in 1968, ending a long and illustrious line including the battleships HMS *Royal Oak* and HMS *Warspite* and the heavy cruiser HMS *Exeter*. There was one more vessel launched after the *Scylla*: the research vessel *Crystal* in 1971. (© Historic England Archive)

Below: South Yard with Devonport Flats Beyond, 2011

A view from the slipway towards the modern buildings used by Princess Yachts with the three tower blocks in Mount Wise, named Lynher, Tavy and Tamar after the local rivers, in the distance. Also visible is the one remaining section of the 'new' ropery building (where the dockyard's ropes were manufactured, originally two very long parallel buildings built around 1756, which replaced Dummer's original ropery building of 1692. The Western building was destroyed by bombing during the war. (© Historic England Archive)

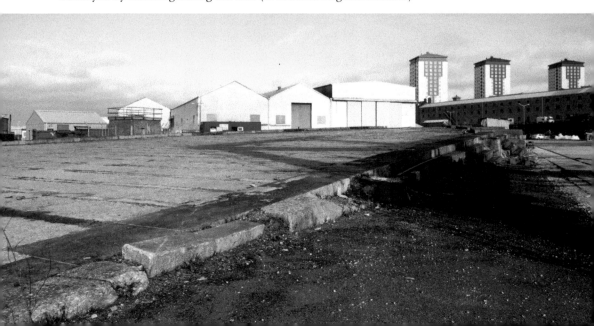

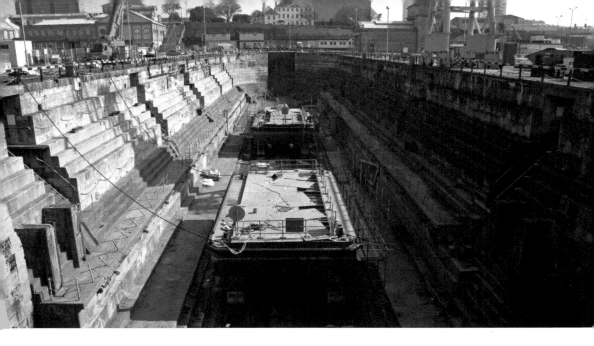

Above: No. 2 Dock, South Yard, 2007

This picture, taken in 2007, shows one of the four remaining dry docks in this area of South Yard, which is now owned by Plymouth City Council. I can remember working on a Leander class frigate in this dock during my time in the dockyard in the late 1960s. The council hopes to lease the docks for maritime, industrial, scientific or technological use. (© Historic England Archive)

Below: No. 3 Dock, 2007

This picture shows the enormous size of this dry dock and the workmanship that went into building it. Both No. 2 and No. 3 dock were rebuilt in the 1840s using granite and incorporating covered walkways down each side to allow safe access for the workforce. Although huge, this is one of the smaller dry docks; I worked on HMS *Ark Royal* in the 1960s when she was in the double dock off No. 5 basin in North Yard, which was probably twice the size of this one. (© Historic England Archive)

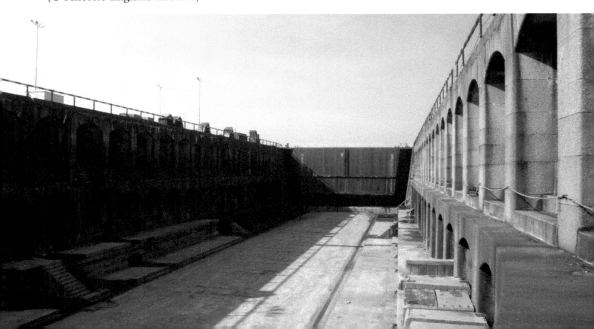

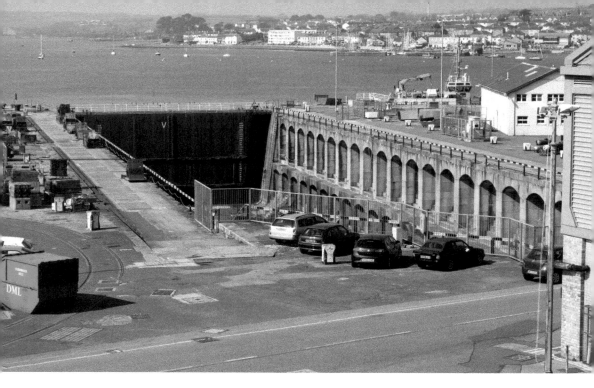

Above: Another View of No. 3 Dock, 2007

This picture gives a better view of the covered walkway running down the side of the dock. Just imagine how much manual labour it took in the 1840s to cut and shape all this granite to incorporate this walkway into the side of the dock. This picture also gives a view across the River Tamar towards the waterfront of Torpoint. (© Historic England Archive)

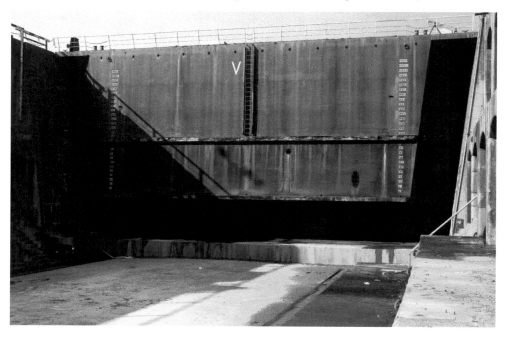

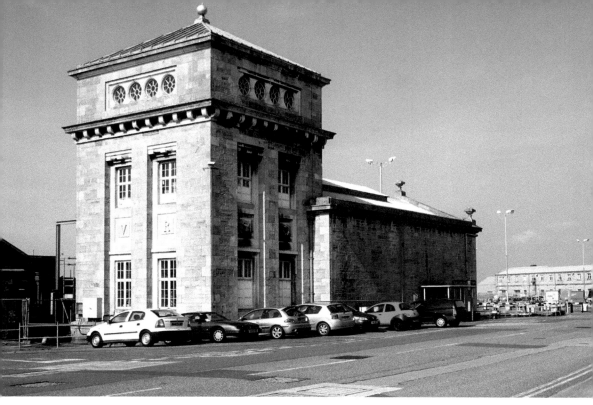

Above: The Main Dock Pump House, 2007
Another of the listed buildings in South Yard, dating from 1851. This lovely old building housed the steam-powered pumps for pumping out the dry docks. The pumping machinery was updated in 1931 and after becoming obsolete it was used as a pneumatic store. (© Historic England Archive)

Right: No. 3 Dock Walkway, 2007
A view, taken in 2007, of the inside of one of the walkways that runs down the side of No. 3 dock. Built from solid granite, this seemingly simple walkway must have represented a huge amount of work in the 1840s. (© Historic England Archive)

Opposite below: Ship Caisson that Seals No. 3 Dock, 2007
This huge steel ship caisson (known to dockyardees as a cassoon) is the 'bung' that seals the dry dock. It contains tanks that can be flooded so the caisson can be sunk into place and then pumped out so it can be floated away to allow a ship to leave. Behind the caisson is up to around 20 feet of the River Tamar. Rubber seals around the edges ensure an almost completely watertight seal. (© Historic England Archive)

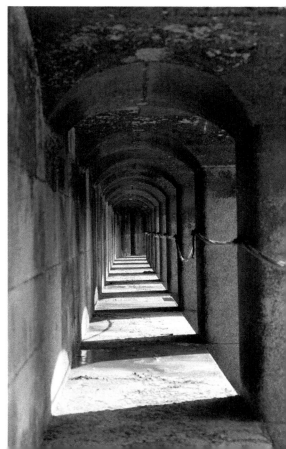

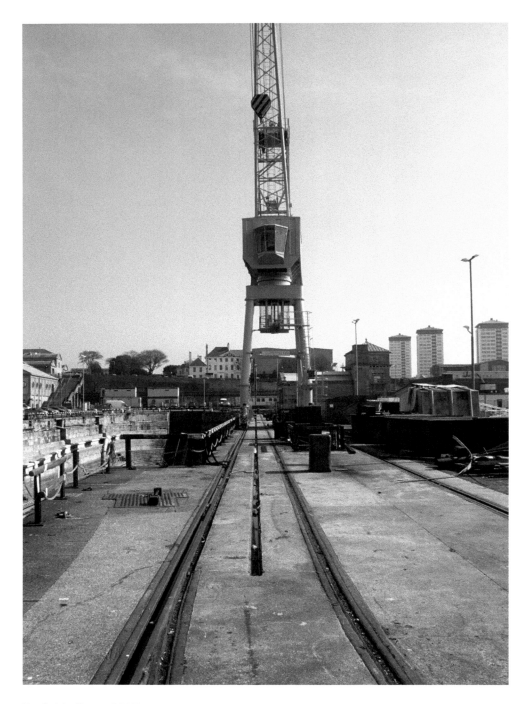

Dockside Crane, 2007
One of the many dockside cranes that serviced the dry docks throughout the dockyard. As can be seen, it ran along the dockside on rails sunk into the surface so as not to impede other vehicles' access. The rails are still there but the cranes are long gone. (© Historic England Archive)

Right: Depth Markings Outside a Dry Dock, 2007
Judging by the barnacles and limpets this picture was taken
from a passing boat on the river at low tide and shows a 'mere'
14 feet of River Tamar outside the caisson that seals the dock.
With all that weight of water pressing against it, it is little
wonder the caisson seals so well. (© Historic England Archive)

Below: The Dockyard from the Air, 1987
This aerial shot shows the whole of the old Devonport
Dockyard, stretching from the northern end of North Yard,
lower left, down to No. 1 covered slipway on the point at
the upper right with Cremyll in the background. (© Historic
England Archive. Aerofilms Collection)

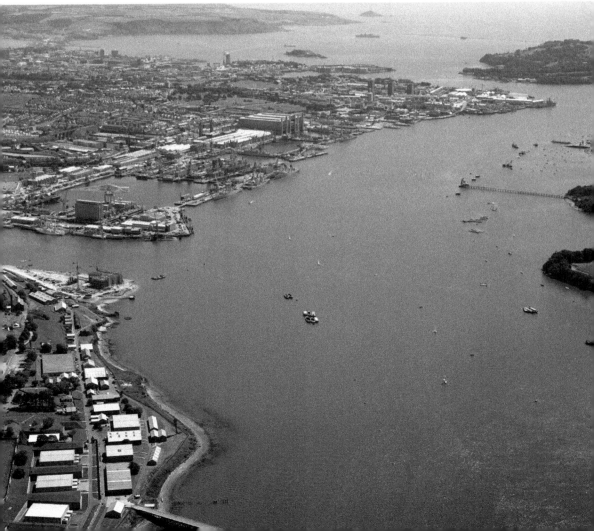

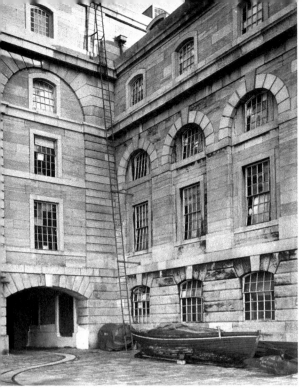

Left: Royal William Yard (aka the Victualling Yard), 1942
This image shows the exterior of the brewhouse at the Royal William victualling yard. Finished by early 1833, it was one of the first buildings to be completed, although the yard was fully operational by the end of that year. The yard has been described as 'architecturally by far the finest of all Naval victualling establishments' and few would argue with that. (© Historic England Archive)

Below: Melville Block at Royal William Yard, 1942
The 'monumental' Melville Square storehouse is located to the south of the tidal basin that allowed lighters and small craft to load and unload directly within the yard. Designed by John Rennie, who had completed the Breakwater in Plymouth Sound after his father's death, this was the main store for the yard. (© Historic England Archive)

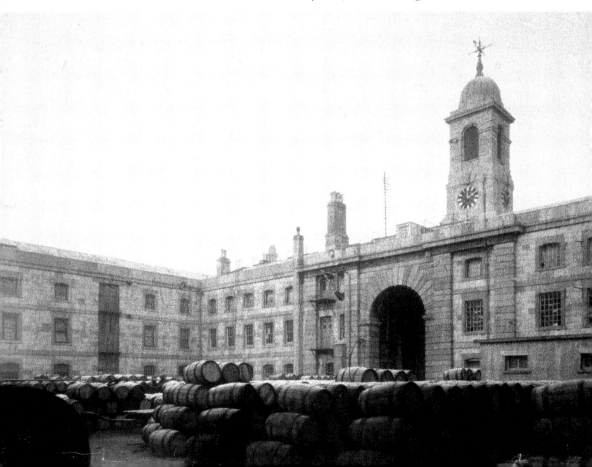

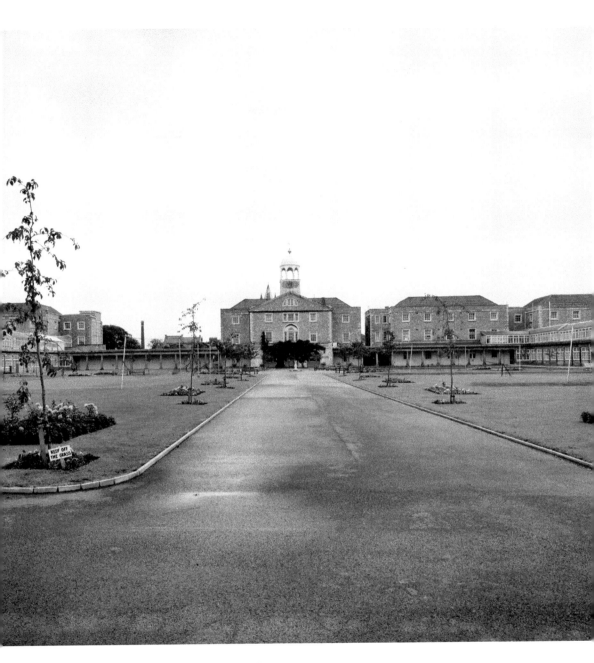

Royal Naval Hospital, Stonehouse, 1992
This shows the main courtyard of the old Royal Naval Hospital. Built on the side of Stonehouse Creek during the Seven Years' War between 1758 and 1762, casualties could originally be delivered by rowing boat to a quay below the hospital. Closed as a hospital many years ago, the lovely old stone buildings are now home to many small businesses and high-end accommodation. (Historic England Archive)

Shops and Commercial Buildings

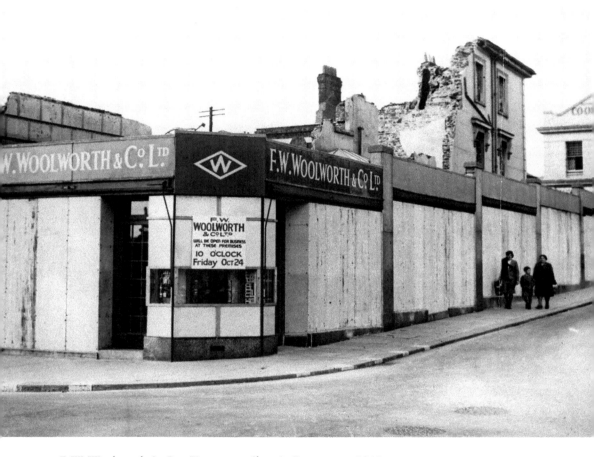

F. W. Woolworth & Co., Temporary Shop in Devonport, 1941

Houses were not the only casualties of the Blitz; most of Plymouth's city centre and large areas of Devonport were flattened so all the major shops in both places had to find temporary accommodation. In Plymouth's city centre many major shops moved to the Pannier Market but this shows Woolworths temporary shop in Marlborough Street, Devonport, in 1941. (Historic England Archive)

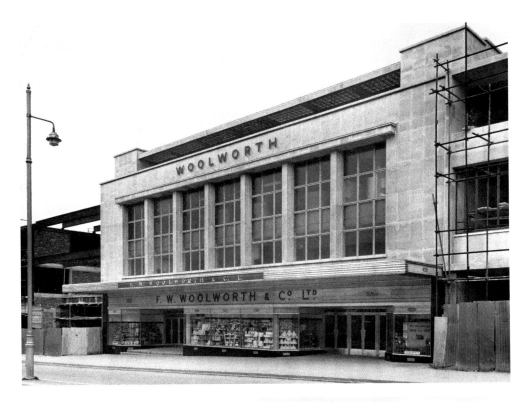

Above: Woolworths Post-war Shop,
New George Street, 1950
This is a shop most Plymothians will
remember – if only for its record
department or its pick-and-mix sweets.
It had a prime position in the New
George Street of the rebuilt Plymouth,
but even this could not beat market
forces and the shop has long gone.
(Historic England Archive)

Right: Woolworths in Plymstock
Broadway, 1963
The once ubiquitous Woolworths had
branches all over the place and this
picture shows the branch at the Plymstock
Broadway shopping centre. Woolworths
ceased trading in the UK in 2008 but they
are still thriving in Australia where they
are the largest supermarket chain with
nearly 1,000 stores, and in South Africa
with over 400 stores. Surprisingly it still
has over 300 stores in Germany as well.
(Historic England Archive)

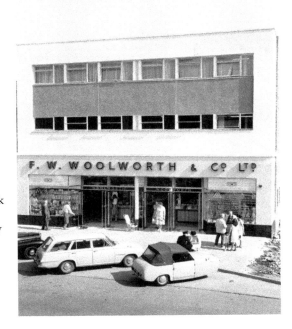

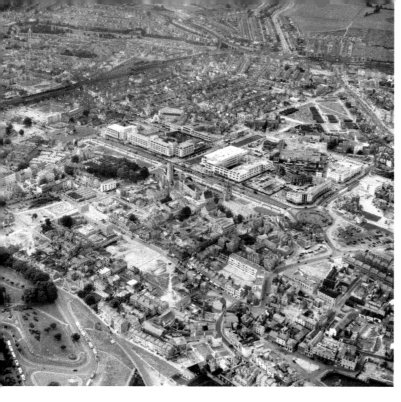

Plymouth's Shopping Centre, 1953
This aerial view of the city centre shows the newly built Royal Parade with the new large shops beside. St Andrew's Church still has no roof and New George Street has many pre-war buildings still in existence. Armada Way is partly complete but Cornwall Street, Mayflower Street and Western Approach are still to come. (© Historic England Archive. Aerofilms Collection)

Royal Parade, 1957
Royal Parade and its shops are all up and running by this date with throngs of shoppers. The centrepiece Dingles store is obvious in its newly built finery, prior to the addition of another storey after fire damage. (Historic England Archive)

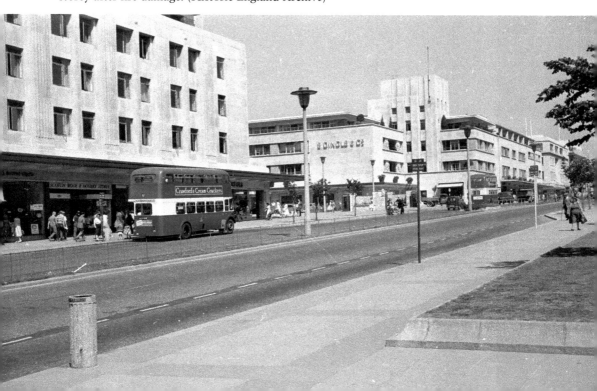

Plymouth City Market, 2010
A view of the roof lights in
the new City Market in 2010.
It looks very modern following
refurbishment, although
it was built between 1957
and 1959. Until 2008 it was
called the Pannier Market, the
name applied to its pre-war
predecessor, which was at the top
of Cornwall Street where many
large shops operated after their
own premises were bombed.
(© Historic England Archive)

Plymouth Drake Circus Shopping Centre, 1971
The original pre-war Drake Circus survived the Blitz but not the developers. It included the landmark Guinness Clock but it was all bulldozed in 1966 and this new two-level shopping centre with the same name opened in 1971 with the then exciting new C&A store, Arcadia and Tesco among others. All this area is now covered by the new Drake Circus Mall.
(© Historic England Archive. John Laing Collection)

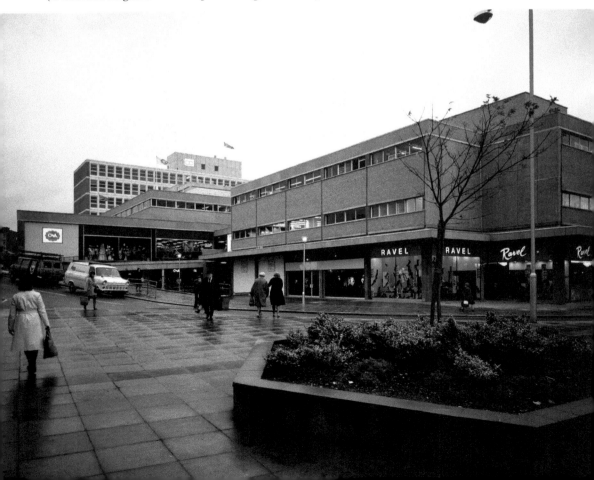

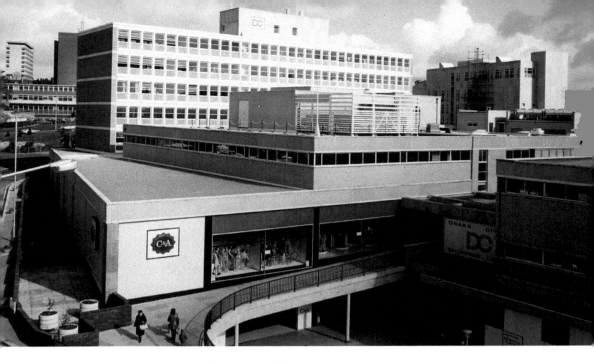

Above: Another View of Drake Circus, 1972
This view from above shows the innovative (at the time!) walkways around the C&A store, which occupied a large part of the upper floor of Drake Circus. Just out of view was the outdoor (but partly covered) escalator, which was very modern in Plymouth at that time. (© Historic England Archive. John Laing Collection)

Below: New George Street, 2010
This shows the view looking up of New George Street in 2010 after the area was partly pedestrianised. As can be seen cars were – and still are – allowed careful access to the area. (© Historic England Archive)

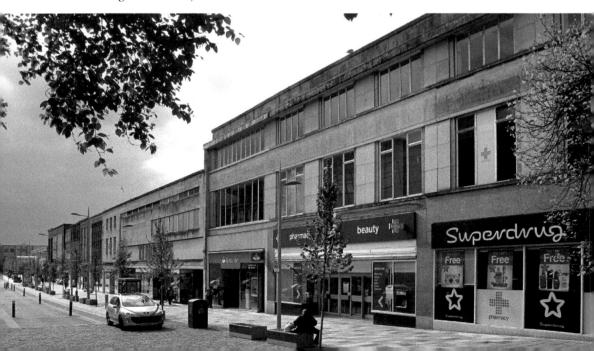

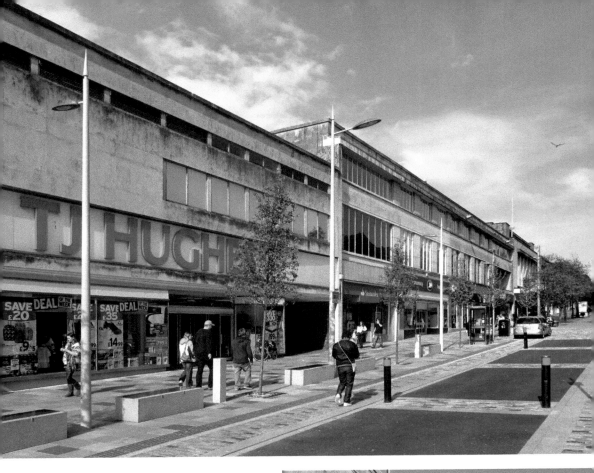

Above: Looking up New George
Street, 2010
This is the view in the opposite direction
to the previous one, looking from the now
long-gone T. J. Hughes shop up towards
the pedestrianised Old Town Street at
the top. Although still pedestrianised,
this area is almost unrecognisable today
with the former large stores replaced
by smaller outlets. (© Historic England
Archive)

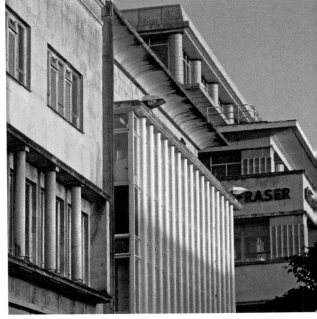

Right: House of Fraser, 2009
The much-modified House of Fraser
store, which was previously known as
Dingles. This unusual view was taken
from the corner of Armada Way and New
George Street looking past the Sundial.
Following a devastating fire it was rebuilt
with an additional storey, which can
easily be seen from this angle. (© Historic
England Archive)

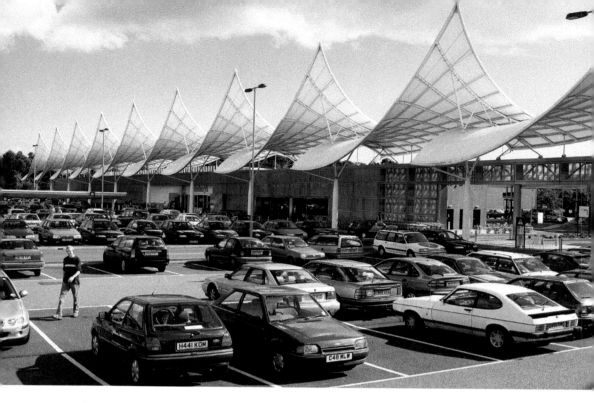

Sainsbury's, 2001
Positioned beside the huge Marsh Mills roundabout where traffic approaches Plymouth from the A38, the awning along the front is supposed to represent sails, a nod towards Plymouth's past. Large, out-of-town superstores like this provide Plymouth's shoppers with most things they want without having to go to the city centre and pay for parking. (© Historic England Archive)

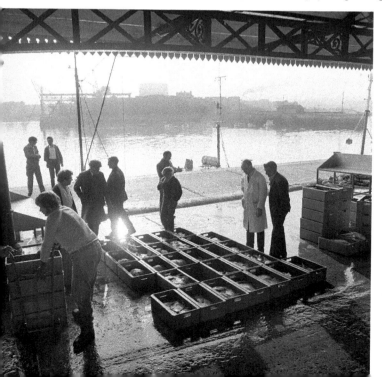

The Old Fish Market, 1973
Taken in 1973, this shows the old covered fish market. At this time it was on the Barbican on a purpose-built quay alongside which trawlers could tie up and offload. In the 1980s a new market was built on the other side of Sutton Harbour and this site is now merely somewhere for tourists to stroll. (© Historic England Archive)

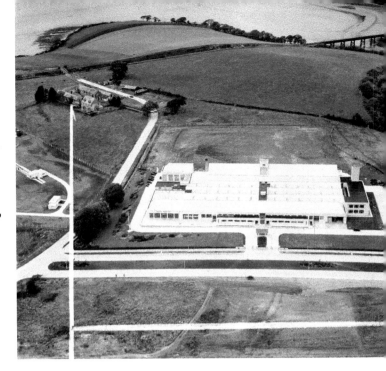

Bush Radio Factory, Ernesettle, 1953
Built in 1949, this factory was only four years old when this picture was taken. It originally produced radios but went on to produce other electrical goods, including televisions. It had many reincarnations, including Rank Bush Murphy and finally Toshiba, but the factory closed in August 2009 when production moved to Poland.
(© Historic England Archive. Aerofilms Collection)

Campbell House, 2007
This art deco building was erected in 1938–39 and for many years was the showroom, stores and offices for A. C. Turner, the local Austin car dealer. Later it became Mothercare and Habitat stores and is now a furniture store. It survived the Blitz and the developers until fairly recently when it was threatened with demolition, although at the time of writing it is still standing.
(© Historic England Archive)

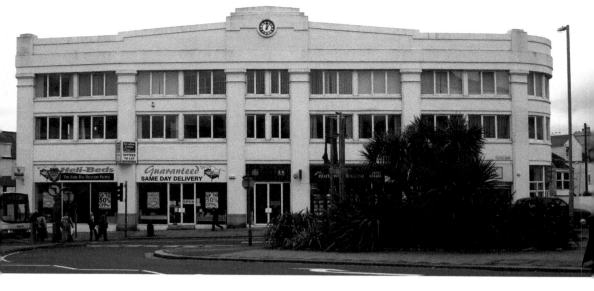

Above: Hyde Park House, 2007

Another old building that originally housed a car dealership. It was owned by Barton Motor Co., the main Morris dealer when Austin and Morris were separate companies, before merging to form BMC. The building was opened by Lord Nuffield, Morris Motors' founder, in 1930. Today it is sublet to a variety of businesses and the harbour substance abuse centre. (© Historic England Archive)

Below: John Foulston's Egyptian House, 2011

This wonderful building is situated in Ker Street, Devonport, near the Town Hall and Devonport Column. All designed by John Foulston, who built so many lovely buildings around Plymouth and Devonport, including the iconic Royal Hotel and Theatre Royal in Plymouth (both lost in the Blitz). The Egyptian House was built in 1823 and has seen many uses over the years. (© Historic England Archive)

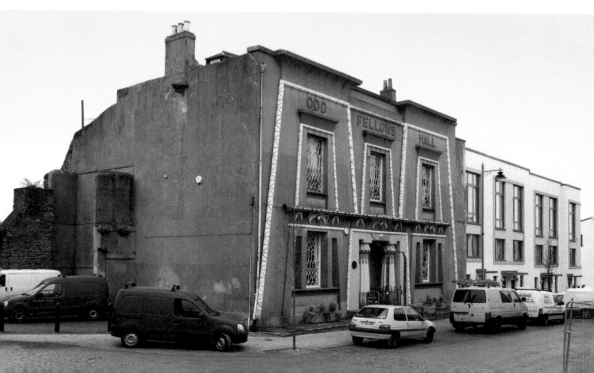

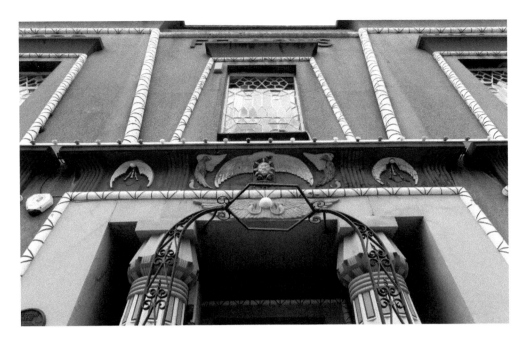

Egyptian House Façade, 2011

Decorated inside and out in an Egyptian style and, amazingly, unscathed by the Blitz, which flattened so much of Devonport including the flats opposite. The house was home to the Odd Fellows Society for 100 years of its existence (1867–1968), and still bears the name Odd Fellows Hall, which can just be seen above the top-floor windows. (© Historic England Archive)

Right and overleaf above: Details of the Egyptian House, 2011

The complete house contains details created in the Egyptian style, as can be seen from these pictures. Since 1989 the house has seen a new lease of life as the very popular Ker Street Social Club. (© Historic England Archive)

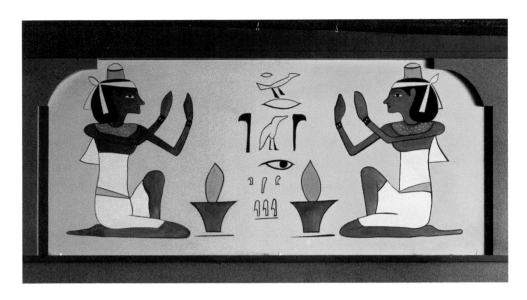

Below: The Ship Building, 1993
Built in 1993 as the base for the Daily Mail Group and its local titles, including *Plymouth's Herald* and *Western Morning News*, it operated until 2013 when the group moved into a more central position in the Millbay area. At one time it was thought this iconic building would be demolished, but it is now Grade II listed and houses a John Lewis call centre. (© Crown copyright. Historic England Archive)

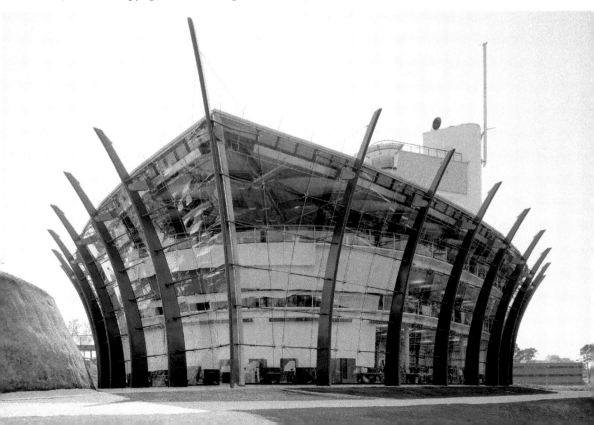

Municipal and Public Buildings

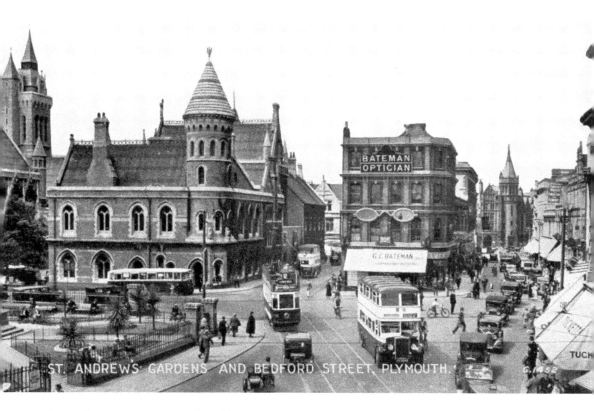

Plymouth's Pre-war Municipal Building, 1939
This was the view from the corner of Old Town Street across St Andrew's Cross. The building left of centre was the old Municipal building, to its left was the Guildhall and to its right was Bateman's opticians. Bedford Street ran alongside Bateman's with many of the large shops, including Spooners and Tucketts, whose awnings can be seen bottom right. All were lost in the Blitz. (Historic England Archive)

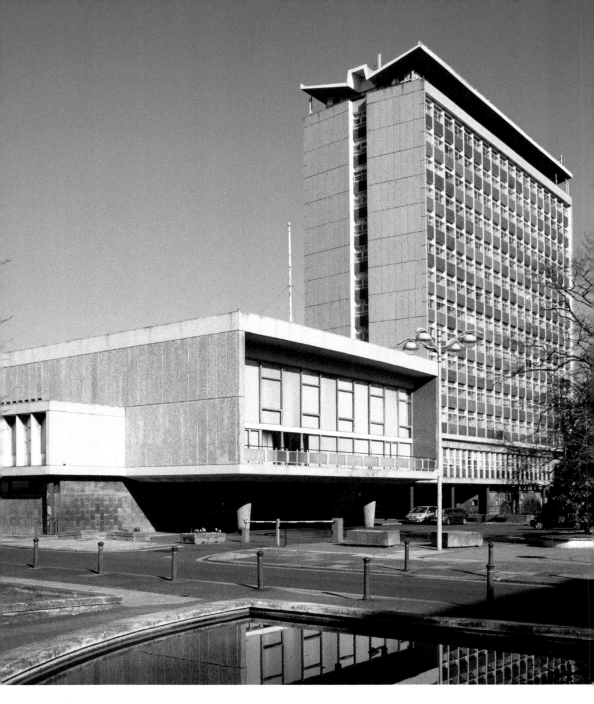

Plymouth's Civic Centre, 2004

Built in 1962, this building used to house most of Plymouth City Council's departments. The adjoining Council House, thought by many Plymothians to be an ugly concrete box, can be seen in front of the Civic Centre tower. Amazingly the Civic Centre was Grade ll listed in 2006 so when the council finally decided it was too expensive to maintain in 2015, it could not be demolished. (Historic England Archive)

Right: View from the Civic Centre, 2007
The view from the Civic Centre is much better than the view of the Civic Centre. In the distance is the Sound with Bovisand left of centre. With its fourteen storeys and, at one time, a café on the roof, it used to give a superb view over the city and if the promised redevelopment as a hotel happens maybe it will again. (© Historic England Archive)

Below: The Council House, 2007
This mural by gifted painter and muralist Mary Adshead adorns the walls of the Council House. Internally it is much nicer than the exterior might suggest. (© Historic England Archive)

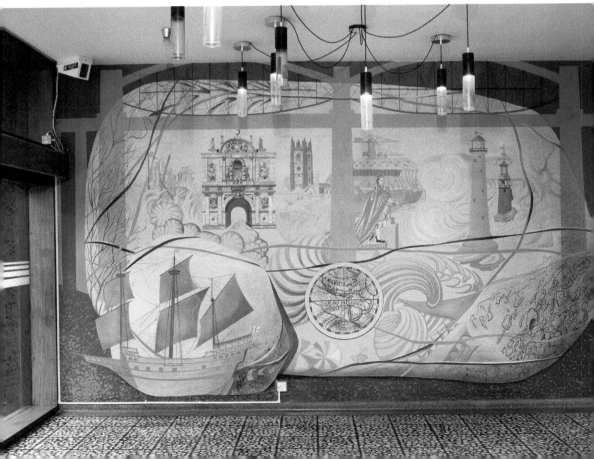

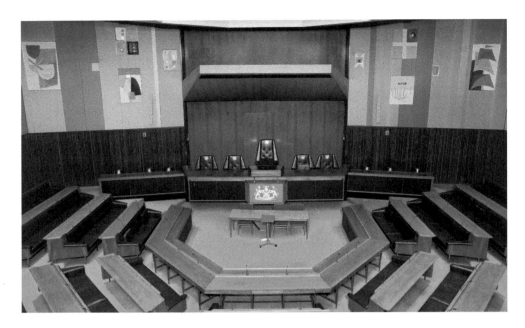

The Council Chamber, 2007

The Council Chamber where the elected councillors meet. The Council House and Chamber are still in use, although the adjoining Civic Centre has not been used by the council for at least two years. (© Historic England Archive)

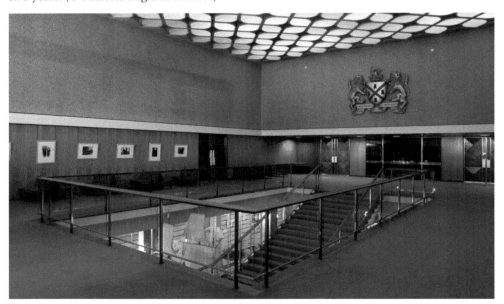

First Floor of the Council House, 2007

A view across the landing inside the Council House showing the suspended ceiling and the city's coat of arms on the wall. (© Historic England Archive)

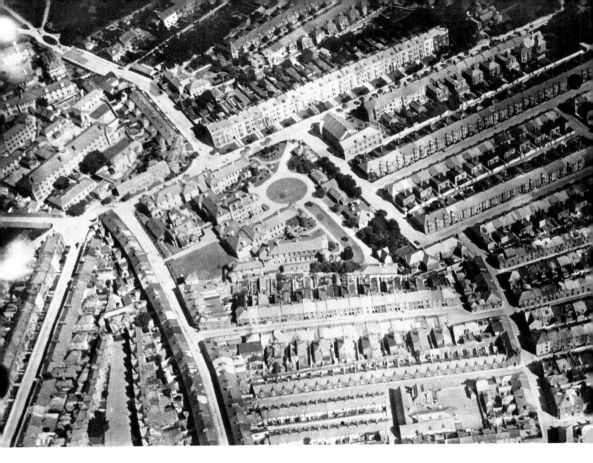

Greenbank Hospital, 1924 (centre of the picture)
Formally known as the South Devon and East Cornwall Hospital, it is known to Plymothians simply as Greenbank Hospital after the road that runs alongside it. Built in the 1830s and much extended, first in the 1880s and again in the early twentieth century, it was hit but not badly damaged during the Blitz. During the 1990s it was closed and demolished with all services being centralised at Derriford Hospital. The site was redeveloped as housing. (© Historic England Archive. Aerofilms Collection)

Lockyer Street Orphanage, 1943
The Devon and Cornwall Female Orphan Asylum was set up in 1834 to adopt female orphans and train them for a life in service, which was the only option for many girls at that time. The site for the building pictured was purchased in 1841 and completed the following year. A hundred years later it was destroyed in the Blitz. (Historic England Archive)

The Prince of Wales Hospital, 1943
Originally opened in 1893 as the Devon and Cornwall Homeopathic Hospital, this was a close neighbour of the previous institution in Lockyer Street. It had many name changes, including the Prince of Wales Hospital, Central Hospital and eventually Lockyer Street Hospital, although, as can be seen in this 1943 picture, it still bears the name Prince of Wales Hospital. Although damaged it survived the Blitz (unlike its neighbour, which was destroyed), but was not centralised by the NHS, closing as a hospital in 1977. (Historic England Archive)

The Old Prince of Wales Hospital Today
After closure the old hospital building was turned into flats and appears to be thriving today. The high-level walkway along the front, which gave access to the first-floor entrances, has gone so entry is now through what was the basement. The impressive old façade to the right (originally the entrance to the stables of the house) had been converted into a dispensary, waiting room and operating theatre in the hospital, but thankfully has been preserved as the grand entrance to many of the flats. (Author's collection)

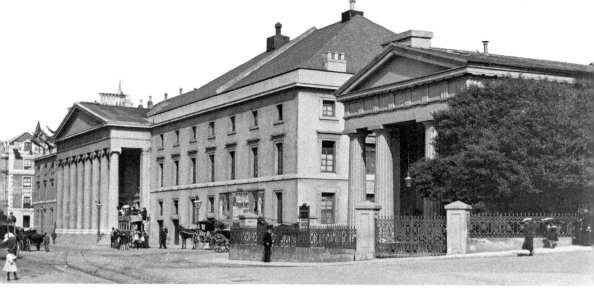

Above: The Theatre Royal, 1893
Possibly John Foulston's masterpiece in the city, the Theatre Royal, with its adjoining Royal Hotel, occupied the corner of George Street and Lockyer Street, at the time the centre of the city. Despite its size and elegance the theatre could not move into a new era with the arrival of cinema, and it was demolished in 1937. The hotel was lost in the Blitz, as was the building nearest the camara, which was Foulston's original Athenaeum. (Historic England Archive)

Below: The Old Customs House, 1941
Originally built in the sixteenth century, this lovely old building on the Barbican housed the 'revenue men', as the officers who extracted customs from traders were called. It was in use until 1820 when the new Customs House on the opposite side of the Parade was built. This building still exists and is currently a bookshop. (Historic England Archive)

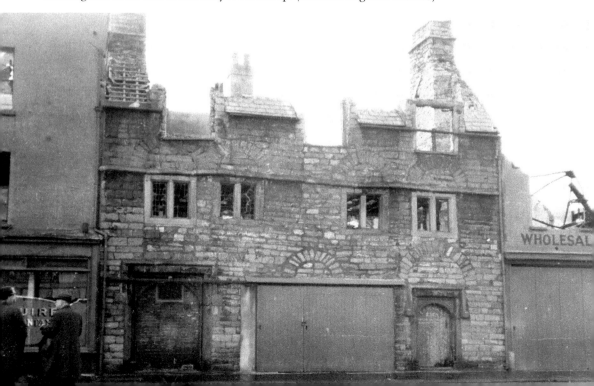

The Old Customs Watch House,
1892–1933
Located on West Pier on the Barbican, this venerable old building was removed in the 1930s. Over the years it had been a police station, customs office and tide survey office. It was demolished along with many of the old eighteenth-century victualling yard buildings to allow better access between the West Pier and Fisher's Nose and eventually to allow for the building of Commercial Road with access to Madiera Road. (Historic England Archive)

The City Museum and Library, 1924 (right of centre)
An aerial view of the city centre showing the old museum and central library on North Hill. These buildings are currently being torn apart and rebuilt to incorporate a history centre, inelegantly but accurately named The Box. (© Historic England Archive)

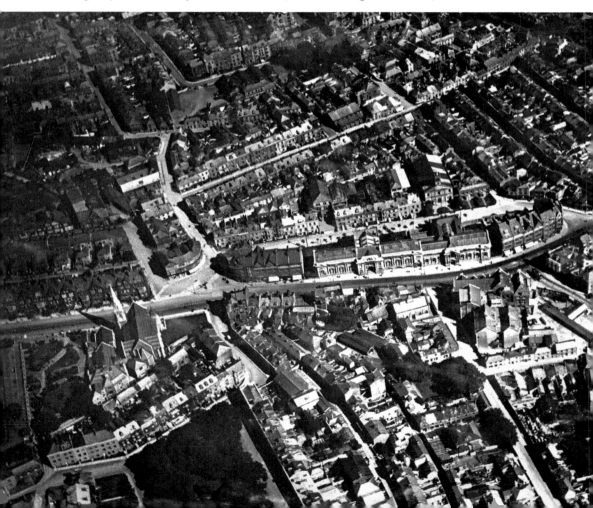

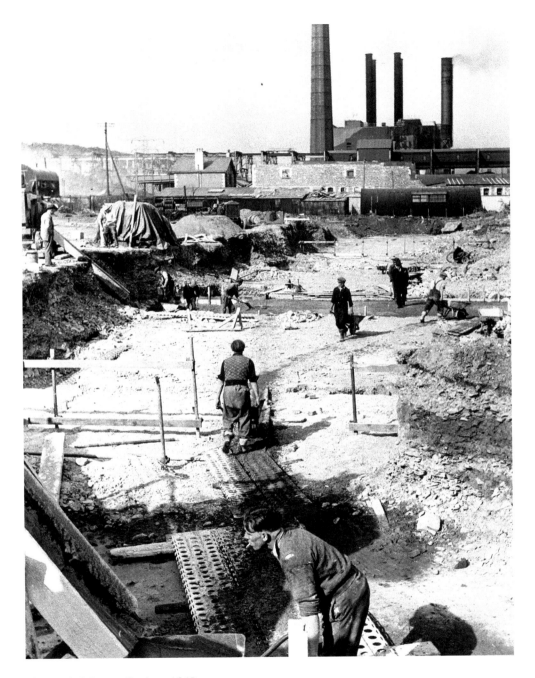

Plymouth B Power Station, 1949
Plymouth's first power station, later called Plymouth A, opened in 1894 initially to supply the city's street lights. By the post-war era a new, larger station was needed. This picture shows excavations needed before the building of the new station could start in 1949. The old power station is in the background. (© Historic England Archive. John Laing Collection)

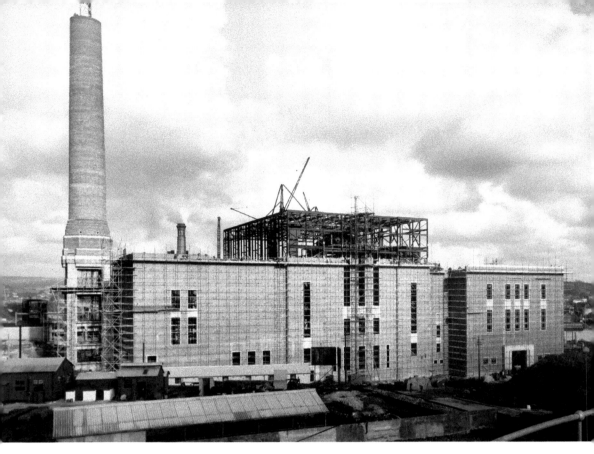

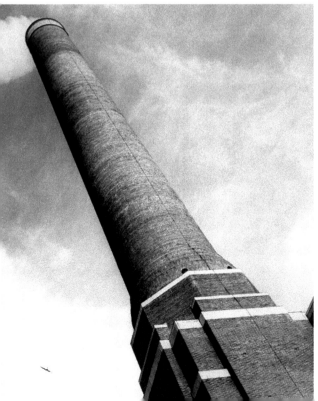

Above: The Power Station Nearly Complete, 1950
The building work for the new power station was nearly complete by 1950, although there was still much work to do inside. It would be at least another year before it produced any electricity. (© Historic England Archive. John Laing Collection)

Left: The Power Station Chimney, 1952
This picture from 1952 shows smoke coming out of the chimney, which presumably means it was producing power by then. (© Historic England Archive. John Laing Collection)

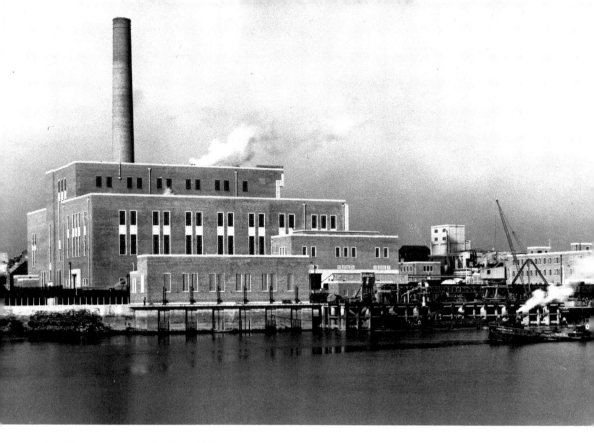

The Power Station Working, 1953
Taken in 1953, this view shows the station – up and running – viewed from the wharf at
Breakwater Road on the other side of the River Plym. The power station is another building
that is now long gone. (© Historic England Archive. John Laing Collection)

Houses

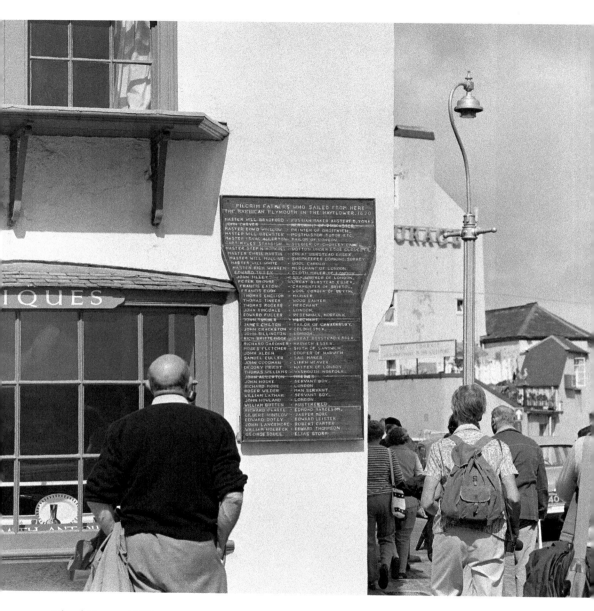

Island House, 1960s

The plaque commemorating the sailing of the Pilgrim Fathers in 1620 is located on Island House, which was one of the houses where they lodged before sailing. Built between 1572 and 1600, it is amazing to think that sections of the quay and certainly the house are still here nearly 400 years later, despite having been considerably damaged in the Blitz. (© Historic England Archive)

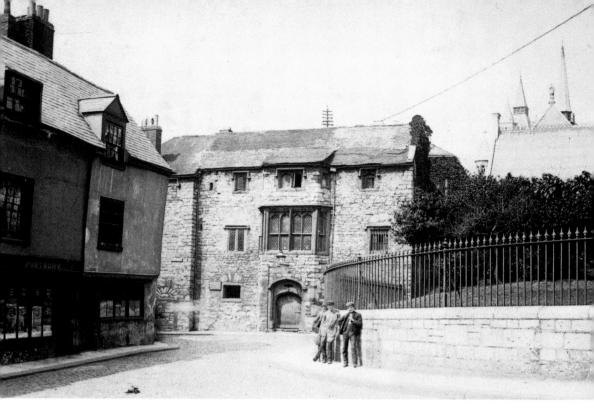

The Prysten House, 1850–1920
The Grade I-listed Prysten House is Plymouth's second oldest house. Dating back to 1498 and extended in 1635, it is 'an excellent example of a large late medieval merchant's house' according to Pevsner. In the past it has been a museum and it is currently a restaurant. (Historic England Archive)

Side View of Prysten House, 1942
The name means 'Priest's House', but despite this it has never been a priest's house. It was probably so named because of its proximity to St Andrew's Church. Amazingly, most of the windows are original and those that aren't are mainly seventeenth century. (Historic England Archive)

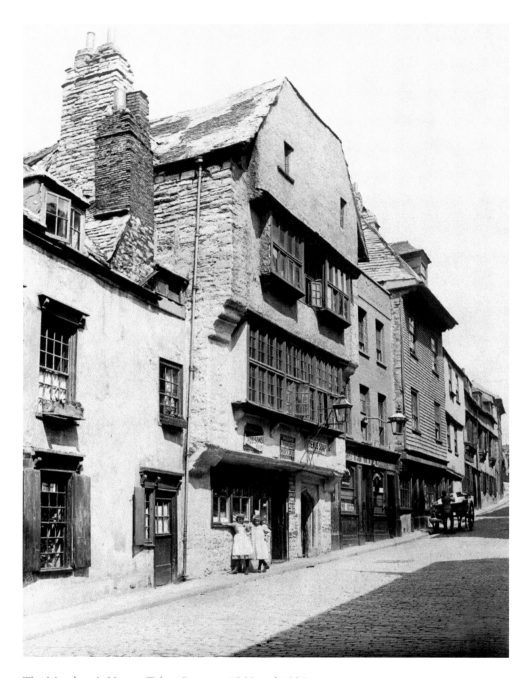

The Merchant's House, Taken Between 1850 and 1920
Located in St Andrew's Street, Plymouth, this house was first owned by one William Parker, a friend of Francis Drake and one-time mayor of Plymouth who lived there in 1608. This is the finest seventeenth-century house in Plymouth. It is now a museum but at the time of writing it is closed for restoration work. (Historic England Archive)

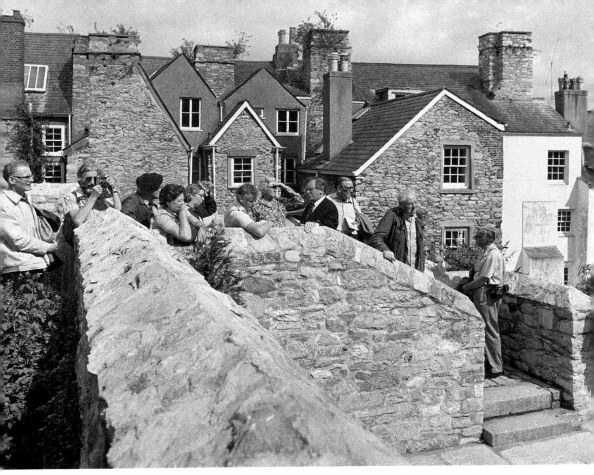

Above: The Barbican, New Street, 1973
Taken in 1973, this picture shows tourists
completely ignoring the backs of the seventeenth-
century houses in New Street. This area of the
Barbican contains many of the oldest buildings
in Plymouth, which belies the street name.
(© Historic England Archive)

Right: No. 12 Notte Street or Regent Street, Taken
in 1942
This is labelled confusingly as both No. 12 Notte
Street and No. 12 Regent Street, which are around
half a mile apart. In my opinion it is more likely to
be Regent Street (although it does look remarkably
similar to the artisan's buildings in Notte Street but
with different neighbours). Wherever it was, this
lovely old house (possibly sixteenth or seventeenth
century) is long gone. (Historic England Archive)

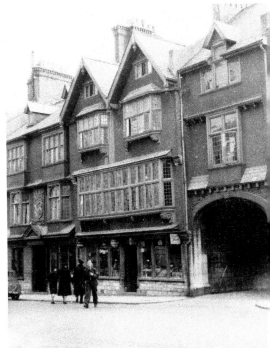

Left: Southside Street, 1942
Thankfully this lovely old building is still with us and still looks essentially the same – although much tidied up and with a fake Victorian street lamp attached. Presumably always used as a shop of some kind (I seem to remember it once as Prete's Ice Cream Parlour, which sold delicious ice cream!) it is now home to a picture framer. (Historic England Archive)

Below: Brunswick Terrace, Exeter Street, 1943
This substantial block of flats in Brunswick Terrace is now long gone. This would have been more or less where Jewson's builders merchant is today, between Sutton Road and North Street. (Historic England Archive)

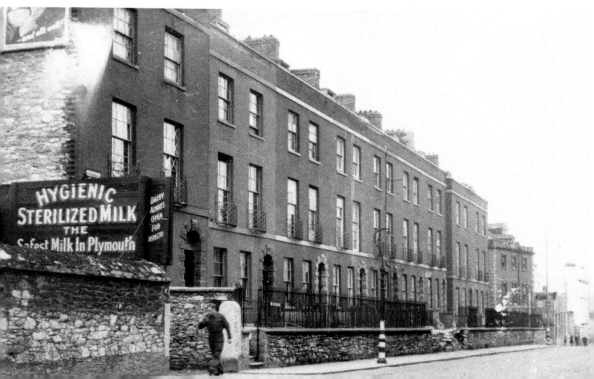

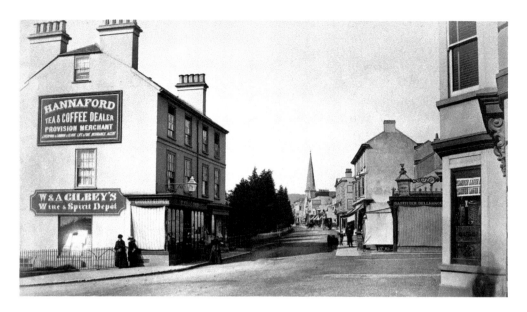

Above: Barbican Street, 1850–96
A long-lost view along one of the streets that ran between the Barbican and Charles Church, possibly Bilbury Street or perhaps even Charles Street. What was not destroyed by the Luftwaffe was destroyed by the council during the post-war rebuilding. (Historic England Archive)

Below: Swiss Cottage, Chaddlewood House, Plympton, 1890–1907
This delightful-looking cottage was in the grounds of Chaddlewood House, Plympton. The house itself still exists, although now surrounded by housing estates when it once was surrounded by open fields. (Historic England Archive)

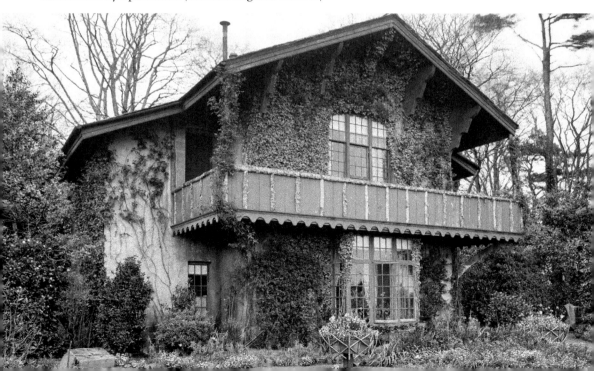

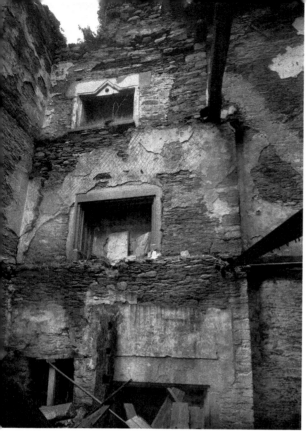

Boringdon Hall as a Ruin, 1971
Amazingly this picture was only taken in 1971, which just goes to show what a superb job the owners of Boringdon Hall have done. Previously home to the Morley family when they were Barons Boringdon, it fell into disrepair after they moved to Saltram in the mid-eighteenth century. It has now been rebuilt and is a five-star hotel. (© Crown copyright. Historic England Archive)

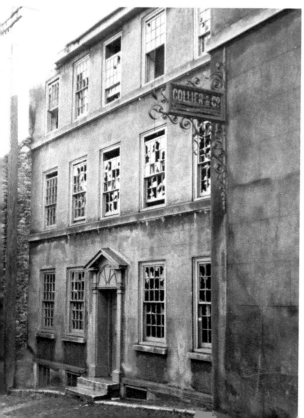

Friars Lane in 1941
This shows a building in Friars Lane in 1941 after being bombed. Friars Lane runs from Southside Street on the Barbican up towards the Hoe. Collier & Co. were local wine merchants, later taken over by Dingles (House of Fraser). (Historic England Archive)

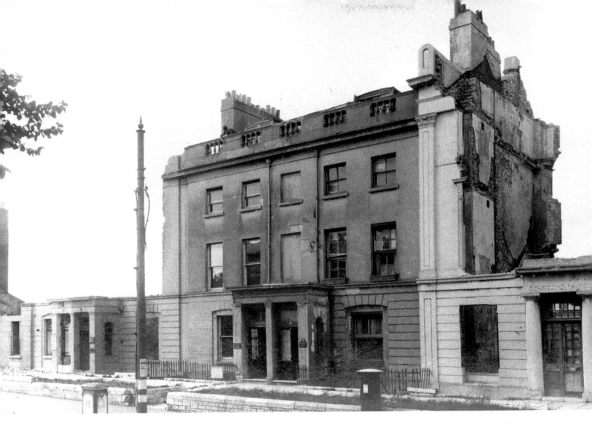

Above: Athenaeum Terrace, 1943
The old Athenaeum was a neighbour of the old Theatre Royal and both were creations of that great architect John Foulston. Athenaeum Terrace was a wealthy area, boasting several solicitors' offices and doctors' residences and even, from 1932, the Plymouth offices of insurance company General Accident. (Historic England Archive)

Right: Island House, 1941
As previously mentioned, Island House was considerably damaged during the Blitz. This picture shows it with most of its roof missing and holes in its walls, but at least the main walls are still standing, allowing the owners to rebuild it into its current glory. (Historic England Archive)

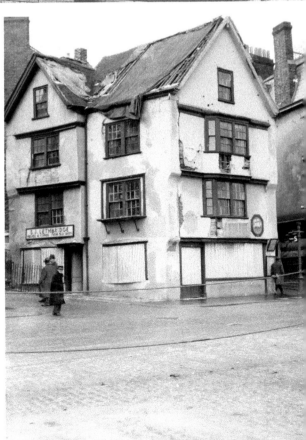

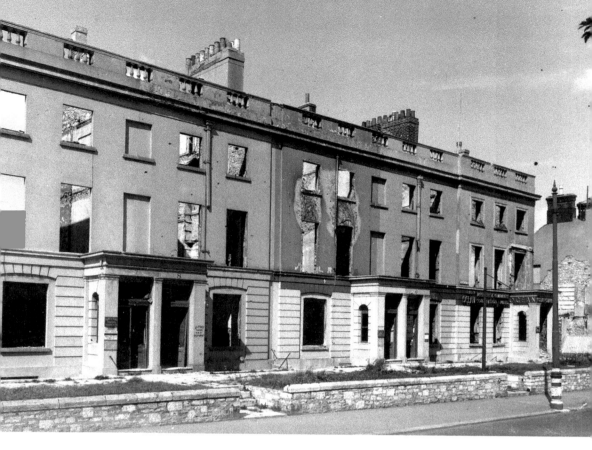

Above and below: Damage to Athenaeum Terrace, 1943
These two pictures show the extent of the bomb damage Plymouth suffered during the Blitz, with most houses pictured here reduced to mere shells with neither windows nor roofs. Houses that were not blown to pieces by high-explosive bombs were burned out by incendiaries with the occupants losing all their possessions. (Historic England Archive)

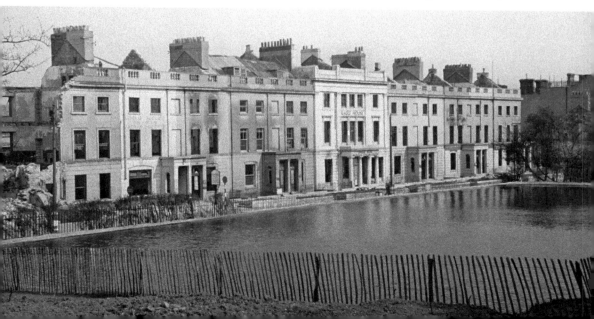

Right: Southside Street, 1942
The premises of Edwin A. Eva, painter, glazier and decorator, who must have struggled to carry on his business after his shop on Southside Street had all its windows blown out. I suppose he was very lucky considering his shop must have been full of combustable materials such as paint, turps and paraffin. Still it did much better than its neighbour, which was completely flattened. (Historic England Archive)

Below: Millbay Road, 1943
This terrace of houses in Millbay Road are shown as mere shells with no windows and no roof. The simplest thing to do was to demolish the whole terrace and rebuild from scratch, but where did the families live in the meantime? (Historic England Archive)

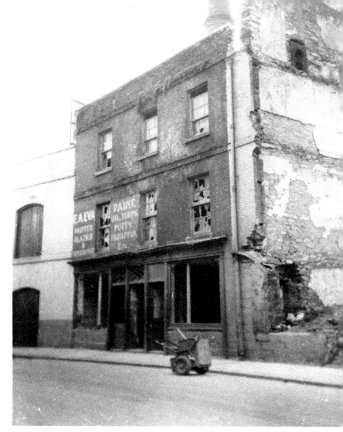

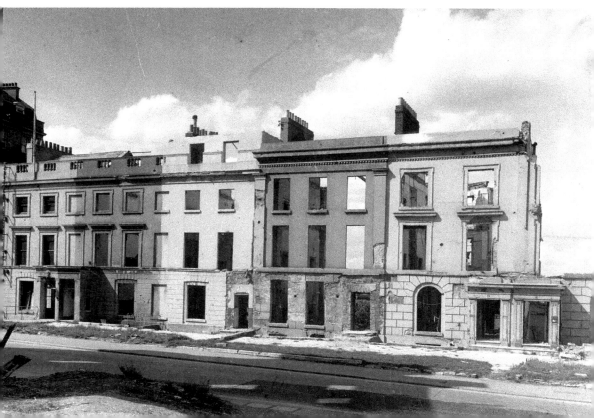

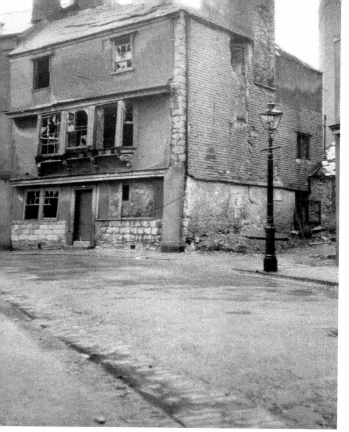

Left: Norley House, Norley Street, 1942

This looks in a very sorry state after the Blitz but in the early nineteenth century Norley House (possibly an earlier one) was home to John Arthur, collector of customs and former Freeman of Plymouth, who died there in 1825. His son, Lieutenant-General Sir George Arthur, was appointed lieutenant-governor of Van Diemen's Land (Tasmania). (Historic England Archive)

Below: Wyndham Square, 1942

The house in the centre of this picture has neither roof nor windows and seemingly no floors either, but surprisingly it was rebuilt. There is an identical house there today, even down to the blanked-out central windows. The adjoining houses were not so lucky, as they have been replaced place by modern buildings. (Historic England Archive)

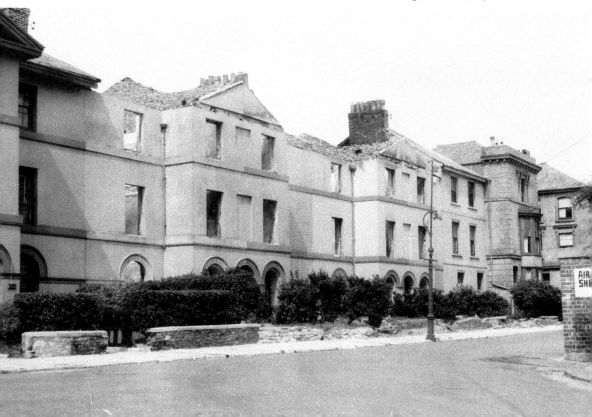

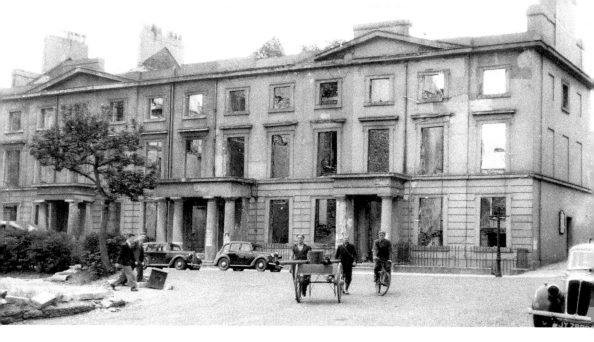

Above: Princess Square, 1942

Princess Square was a very high-class area of pre-war Plymouth, home to solicitors, doctors, many prosperous businesses and even the Freemasons' Hall. This terrace was one of two on the south side of the square, nearest the Hoe. To show just how affluent this area was, R. Humm, the local Rolls-Royce dealer, had a base on the corner of Princess Square and Westwell Street. The square was mainly designed by Foulston. (Historic England Archive)

Below: Another View of Princess Square, 1942

This picture shows the corner of Princess Square where Westwell Street joined. The central building was Barclays Bank, further proof of how affluent this area was. The centre of the square had been converted into Plymouth's first ever car park and both pictures show evidence of many cars in the area, reinforcing the high-class description at a time when few people had cars. (Historic England Archive)

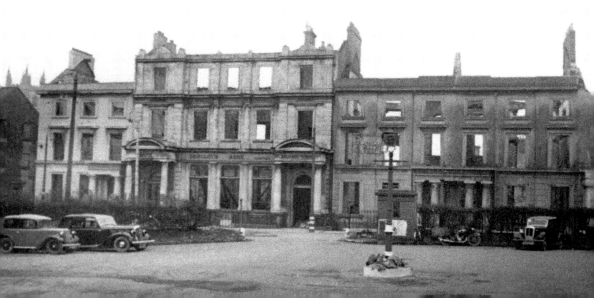

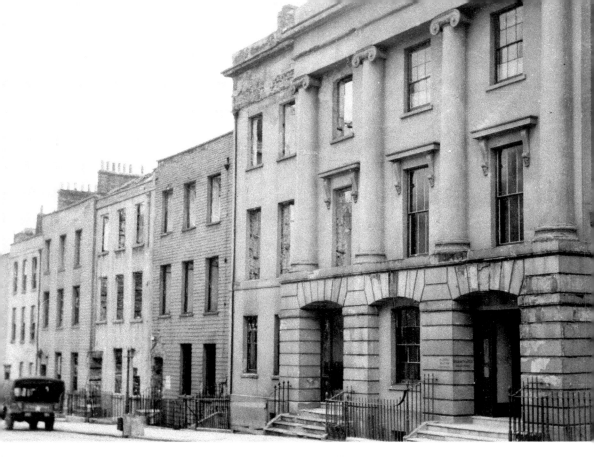

Above: Ker Street, Devonport, 1943
This was the terrace of flats on the opposite side of the road from the previously mentioned Egyptian House, and was yet another Foulston design. This side of the street was bombed out during the Blitz, so it was demolished and replaced with more modern flats. (Historic England Archive)

Left: Post-war Rebuilding at Efford, 1947
This picture shows builders laying out the foundations and starting to build new houses at the end of Pike Road near the junction with Old Laira Road, with the high ground of Mount Gould in the background. With the city centre bombed out there was a general move out towards what had been the suburbs and surrounding farmland. (© Historic England Archive. John Laing Collection)

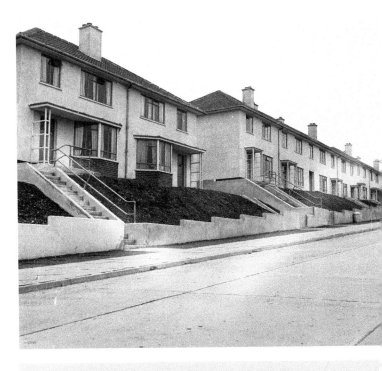

'Easiform' Houses at Efford, 1947
The finished product. Built for Plymouth City Council for use as council houses, they were known as Easiform and, as can be seen, they were all alike so they were easy to build and obviously sound because they have survived well. I have a relative who still lives in one and it is very good. (© Historic England Archive. John Laing Collection)

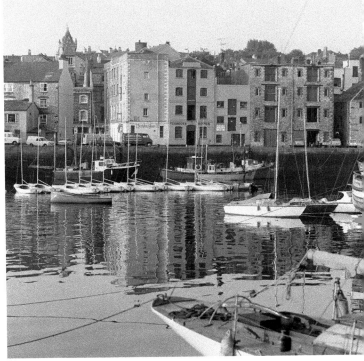

New Buildings around Sutton Pool, 1960s
These buildings, some of which were converted warehouses, were precursors of the huge numbers of new flats that have sprung up around Sutton Pool since the war, and the numbers continue to rise to this day. Waterside dwellings, of course, fetch a huge premium and you don't get much more waterside than this. (© Historic England Archive)

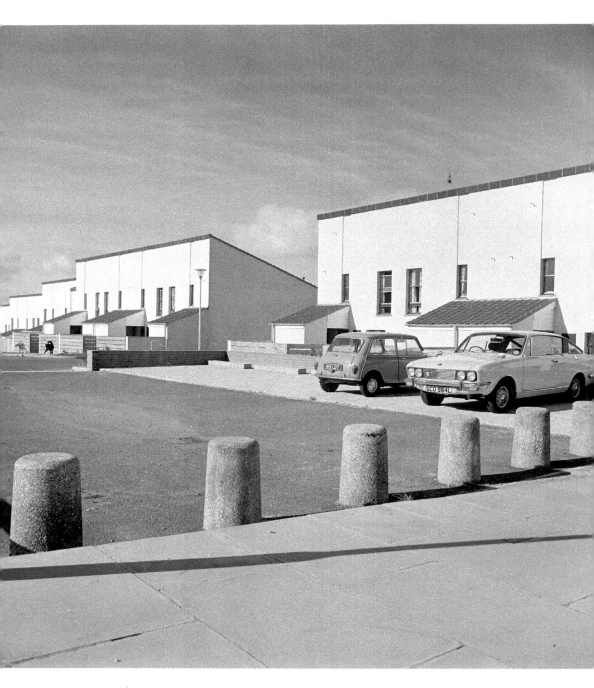

Tamerton Foliot New Houses, 1967–75
These modern buildings are at Tamerton Foliot, at one time a village outside Plymouth, although it has now been absorbed into the city and grown rapidly with the new estates on the outskirts dwarfing the old village. (© Historic England Archive)

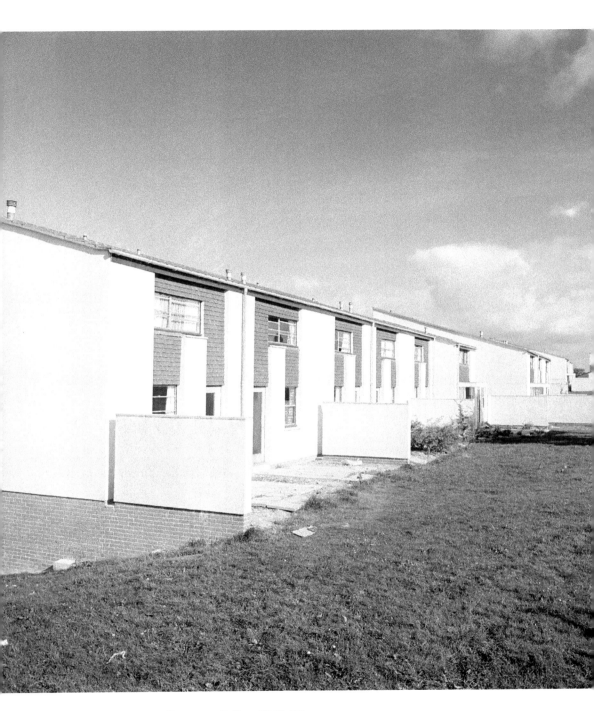

More New Houses at Tamerton Foliot, 1967–75
Another glimpse of some of the new houses that have enveloped Tamerton Foliot.
(© Historic England Archive)

Transport

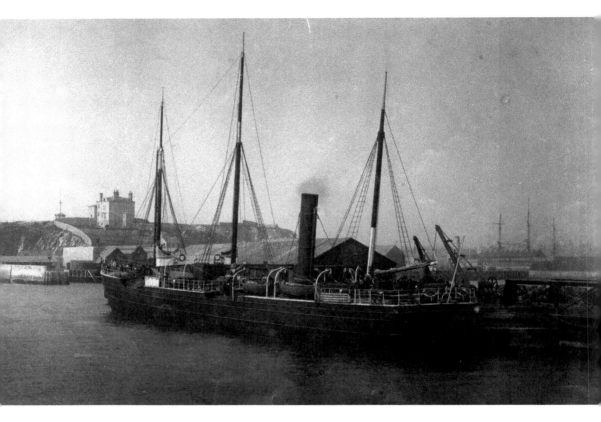

Above: The *Avoca*, 1878

It is possible that this was the famous *Avoca* that, while plying in Australian waters, was involved in a gold bullion theft. I can only find records of one ship named *Avoca*, built in 1870, which later worked between Australia and Ceylon. Five thousand gold sovereigns were stolen from her strongroom by her carpenter. She sank off Dungeness en route to Dublin in 1890. Note only one house on the Hoe is in the background. (Historic England Archive)

Opposite above: Millbay Docks, 1937

Comparing this picture with a modern one, it is amazing how little has changed in the meantime, given that the nature and business of the port has changed so much in the time. Apart from some of the western side of the inner dock having been infilled the dock looks very similar today. (© Historic England Archive. Aerofilms Collection)

Opposite below: Sutton Harbour, 1937

Again the outline of the inner harbour is almost identical today, but of course the nature of the harbour has changed completely. In 1937 the harbour was tidal and there were a few small boats moored. The fish market, just out of shot, would have serviced many trawlers. (© Historic England Archive. Aerofilms Collection)

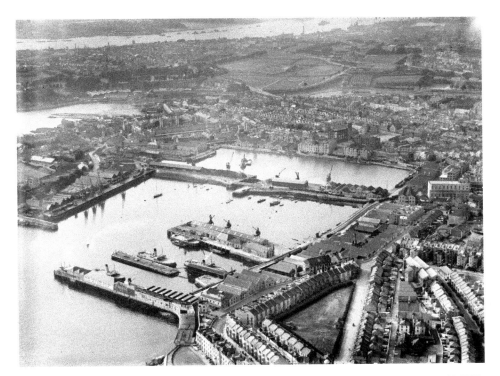

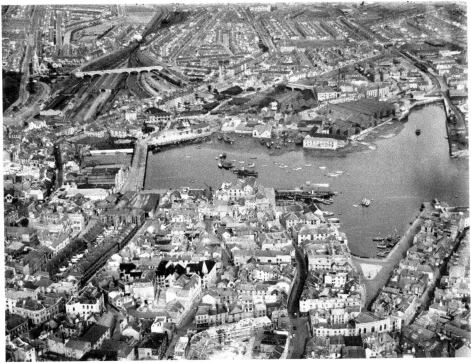

Trawlers Alongside the Barbican Wall, 1960–70
Just a few of the trawlers that would have kept the fish market busy even as recently as the 1960s when my uncle ran the fishing department of Mashford's boatyard here. There are far fewer today and the fish market is now the other side of the harbour. (© Historic England Archive)

The Lee Moor Tramway, 1893
The Lee Moor Tramway brought china clay from the quarries on Lee Moor down through Boringdon Wood, via an inclined plane, and across the Plymbridge Lane here on a wooden trestle bridge. From Plymbridge the clay was carried in horse-drawn wagons across the GWR tracks (having right of way over the mainline trains!) and then alongside the main railway lines to Sutton Harbour for shipping where it was needed. (Historic England Archive)

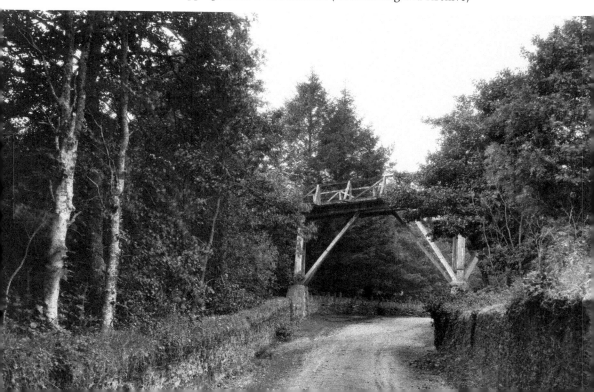

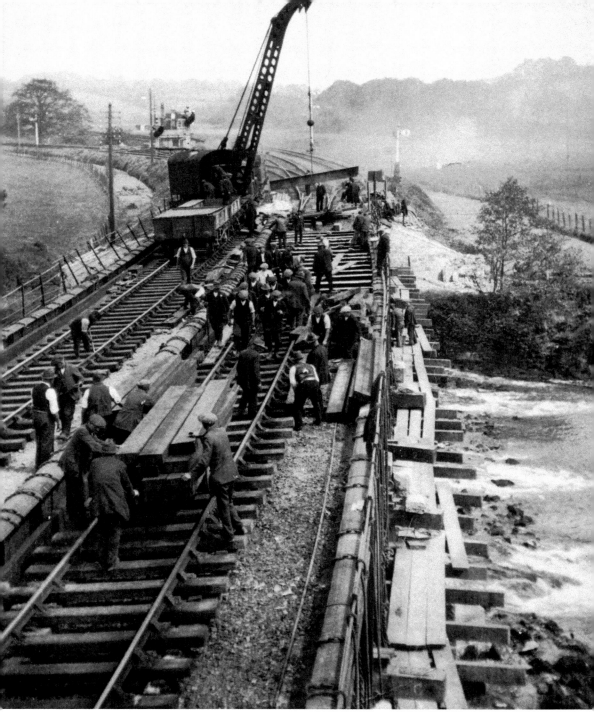

Railway Crossing the Plym, 1920–29

This picture, taken between 1920 and 1929, seems to show work being done on the bridge that passes over the River Plym beside Sainsbury's. This bridge carries the two tracks of the main line between Plymouth and London and is little changed to this day. (Historic England Archive)

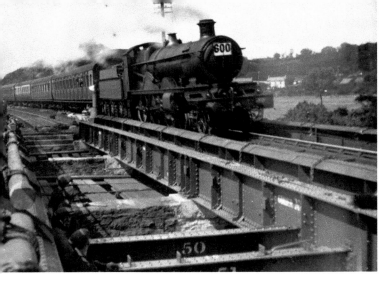

Train Crossing the Plym, 1920-29
A Star class GWR locomotive crossing the Plym towards Plympton with Laira Green in the background. The track can be seen snaking its way alongside the Plym Estuary towards the Laira workshops and on towards Plymouth. (Historic England Archive)

Friary Station, 1937
This aerial shot shows the old Friary station, which opened for goods in 1878. In 1891 it became a passenger terminus as well as goods, eventually servicing branch lines to Plymstock and Turnchapel, but it retained its branch to Sutton Harbour and on to Cattedown. Passenger services ended in 1958 and the station was closed in 1976. Most of the area this side of St Jude's Bridge is now a retail park. (© Historic England Archive. Aerofilms Collection)

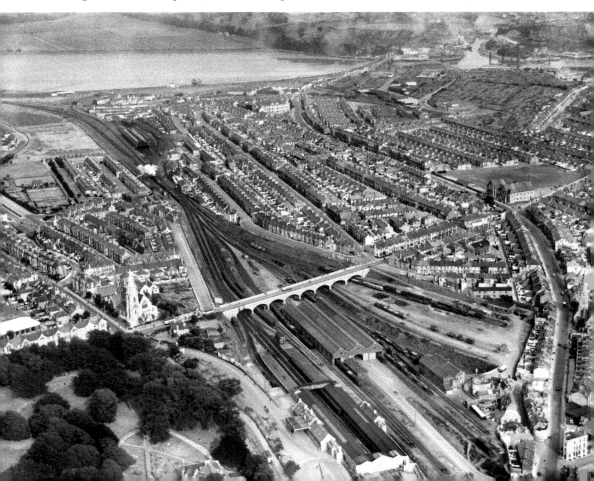

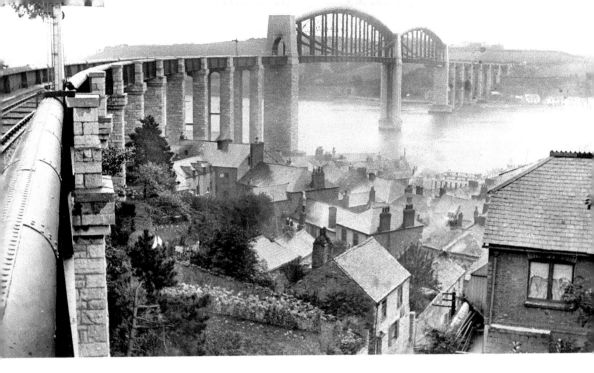

Above: The Royal Albert Bridge, 1901
Taken from Saltash, this shows Brunel's beautiful Royal Albert Bridge long before it was joined by the road bridge in 1961. Opened by Prince Albert in 1859, Brunel was taken across on an open wagon two days later because he was too ill to attend the opening. He died six months after. (Historic England Archive)

Below: An Aerial View, 1959
This must be one of the last shots to show the Royal Albert Bridge in splendid isolation because it was in this year that construction work began on the Tamar road bridge, which now runs alongside the railway bridge. This picture shows the beautiful simplicity of Brunel's design. (© Historic England Archive. Harold Wingham Collection)

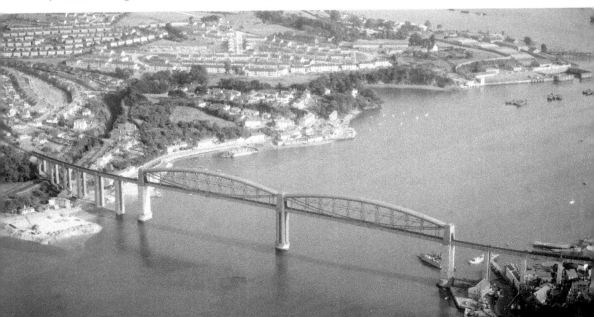

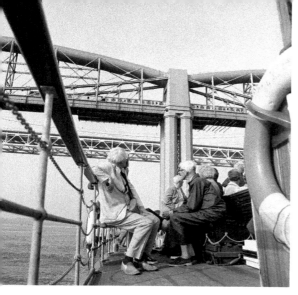

Both Tamar Bridges, 1973
Taken from a pleasure boat called the *Scomber* as it passed under the bridges, this shows the Royal Albert rail bridge with the new Tamar road bridge behind. What amazes me is that Brunel's bridge is still working 150-plus years later, with very little modification to his original design. (© Historic England Archive)

Roborough Airport, 1959
This is very close to my heart, both as a local and as a pilot. This shows the airport as it was, with three grass runways as built in the 1930s. It had been taken over by the Royal Navy in the late 1930s and then by the RAF. Post-war it was gradually built up and became Plymouth City Airport with just two tarmac runways. The western end has now been built on and the airport is closed for political reasons. (© Historic England Archive. Harold Wingham Collection)

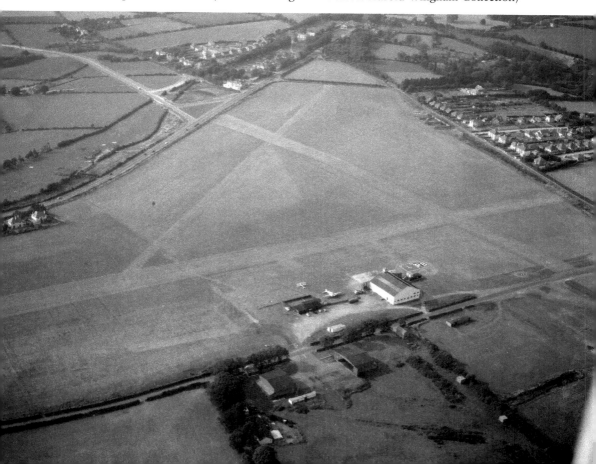

Leisure

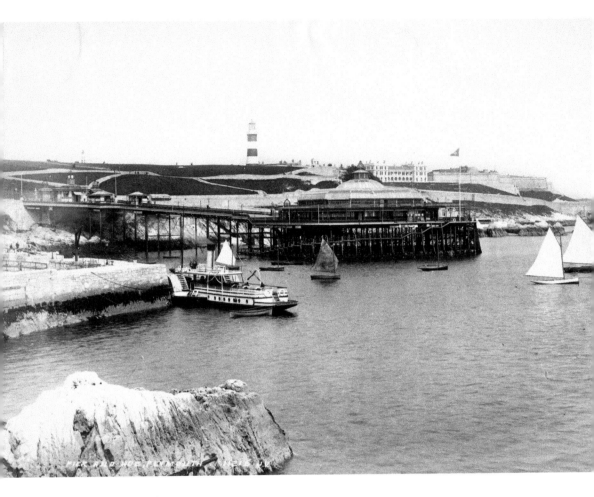

The Pier, 1884–1920
This (unusual at the time) view of the pier with the Hoe and Citadel beyond gives a good idea of the atmosphere. This was the place where Plymothians could come and walk for free, enjoying the beautiful views across the Sound to Mount Edgcumbe, Drake's Island or Bovisand. There was of course an admission charge to the pier, a 'popular penny', but anyone could walk along the front or up around Smeaton's Tower for free. (Historic England Archive)

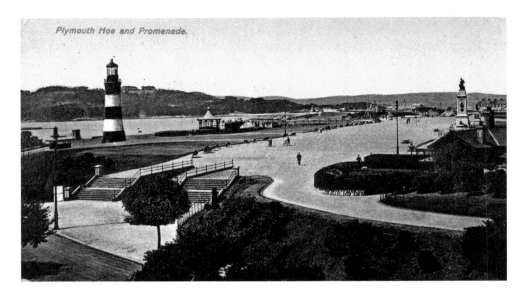

The Hoe from the Citadel, 1920–30

This postcard shows the Hoe from the opposite direction to the previous one and at a slightly later date. The café, right of centre, is still the same to this day, as are the gardens surrounding it. The octagonal lookout, seen here to the left of Smeaton's Tower, is still there but the bandstand to the right is long gone, having been broken up for scrap during the Second World War. (Historic England Archive)

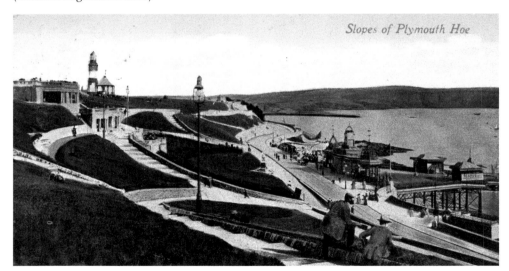

The Belvedere, 1905–10

As can be seen here, the Belvedere, known as 'The Wedding Cake', used to be at the head of the pier, which predated it, and provided a beautiful backdrop for the pier. The Belvedere was built in 1891 whereas the pier had been opened in 1884. The Belvedere was undamaged in the Blitz, but the pier was burned out and finally demolished in 1953. (Historic England Archive)

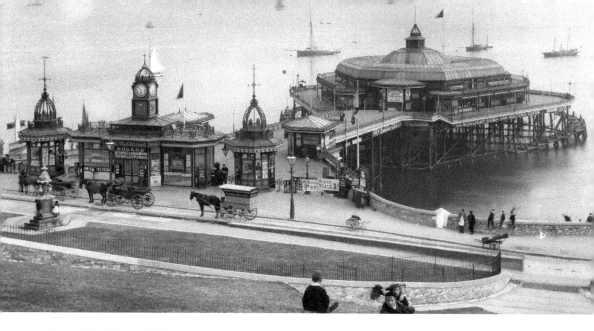

Above: The Pier in 1893

Known as the Banjo Pier because of its shape, it was very popular in its early days, with concerts, roller skating, dancing as well as boxing and wrestling contests. In later years it struggled financially and by 1938 receivers were called in, so in some ways being bombed might have been a blessing in disguise. It was in such financial trouble it could not even be demolished until the War Damage Commission made a payment. (Historic England Archive)

Below: The South Africa War Memorial, 1902–09

Finished in 1903 as a memorial to the officers and men of the Gloucestershire, Somerset and Devon regiments who had died fighting in the Boer War of 1899–1902, it was unveiled by Lady Audrey Buller, wife of General Sir Redvers Buller, the original commander-in-chief of forces in the war. Although garishly coloured, it does represent a good view over the city, with the Guildhall, Municipal building and St Andrew's Church all visible in the background. (Historic England Archive)

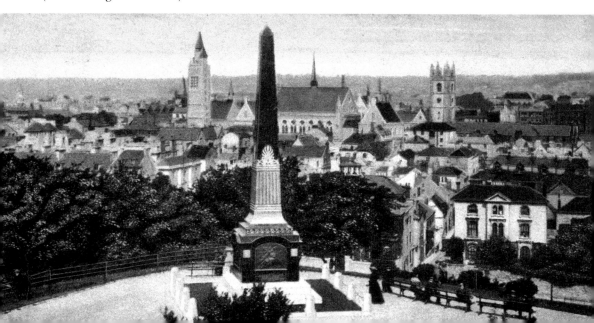

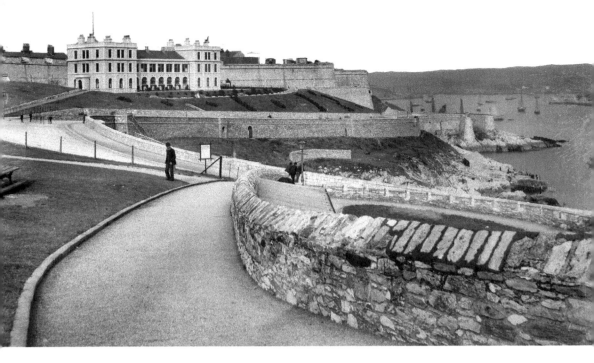

Above: The Royal Citadel from the Hoe, 1893
A view of the Royal Citadel. In front is the laboratory of the Marine Biological Association, which has been there since 1888. Since that time it has done an enormous amount of research into marine biology, leading directly or indirectly to several Nobel prizes. (Historic England Archive)

Below: A View from the Hoe over the Old City Centre, 1850–1920
A much clearer view over central Plymouth from the slopes of the Hoe showing the Guildhall, municipal building and St Andrew's Church in the background. In the foreground are some of the large villas that bounded the area – all now long gone. (Historic England Archive)

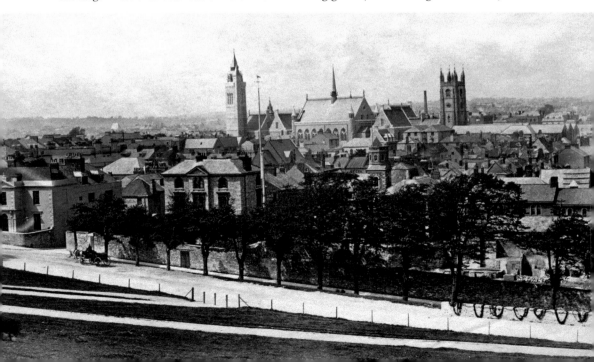

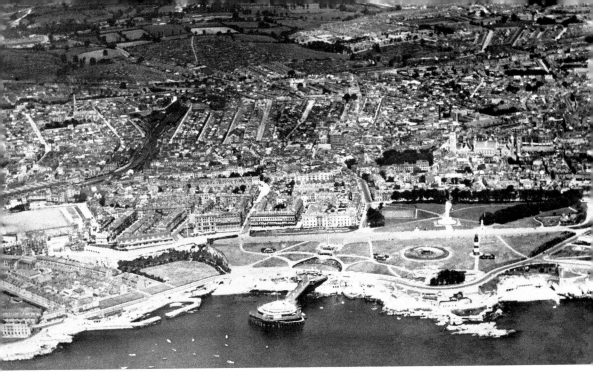

The Hoe from the Air, 1924
This picture shows the large open space of the Hoe, the Belvedere and pier and the earlier Tinside swimming pool, which preceded the well-known lido that opened in 1935. Also of interest is the background with large areas of fields and open country visible beyond the railway viaduct at Pennycomequick. (© Historic England Archive. Aerofilms Collection)

The Hoe, 1948
In comparison, this picture shows what a difference twenty-four years and the Blitz have made. The new semicircular Tinside Lido is obvious and the pier has been reduced to a mass of girders. From this angle it is possible to make out that the city has grown noticeably, although much of the built-up area to the top right is Plympton, then still a separate town. (© Historic England Archive. Aerofilms Collection)

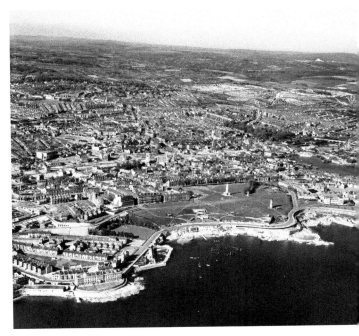

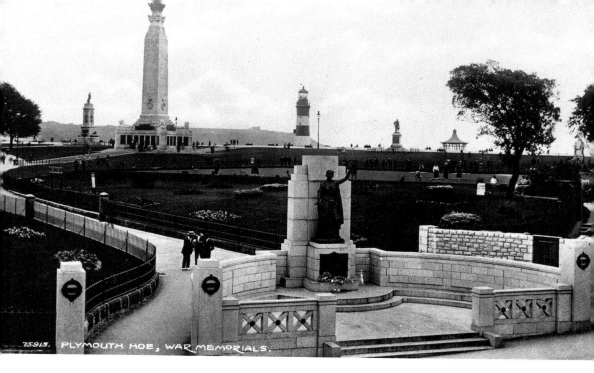

75915. PLYMOUTH HOE, WAR MEMORIALS.

The War Memorial, 1918–30
In the middle distance, centre left, is the new war memorial, at that time simply commemorating the local dead of the First World War. Sadly many more names have been added to it since then, mainly commemorating the dead of the Second World War. The fancy entrance is still there in Osborne Place but sadly the clubhouse belonging to the Bowls Devon club makes this view of the memorial now impossible. (Historic England Archive)

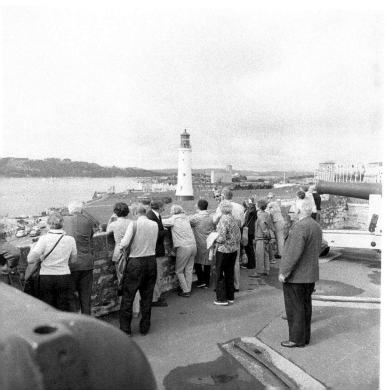

The Hoe from the Citadel, 1973
A group of tourists on the ramparts of the Royal Citadel enjoy one of the best views in the area over the Hoe, the Sound and across towards Mount Edgcumbe, with Drake's Island just out of shot on the left. Most prominent in the foreground is Smeaton's Tower, which was the Eddystone lighthouse between 1759 and 1877 when erosion made it unsafe so it was dismantled and rebuilt on the Hoe. (© Historic England Archive)

Above: Devonport Park, 1900–30

This is Devonport's own green space, a place for locals to walk and enjoy nature. It became a park when the military released the Ordnance Fields in the 1850s and converted them by subscription into the park we see today. This is a view of the Napier Fountain, sadly a fountain no longer, which was installed as a memorial to Sir Charles Napier in 1863 just inside the Fore Street entrance to the park. (Historic England Archive)

Below: The Sicilian Fountain and Bandstand, 1902–33

This view, taken from in front of the beautiful Higher Lodge, originally a refreshment pavilion building and now a care home, shows the Sicilian fountain and bandstand, later additions to the park. The Devonport Borough Council minutes for 1896 state: 'A vote of thanks [was given] to Mr and Mrs Bennett for their gift of a handsome Sicilian Marble Fountain to be erected in the Park.' Sicilian marble, still used today, is of very high quality so this was a very 'handsome' gift and explains the name. (Historic England Archive)

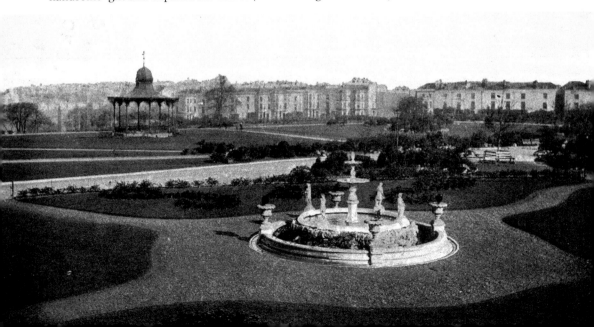

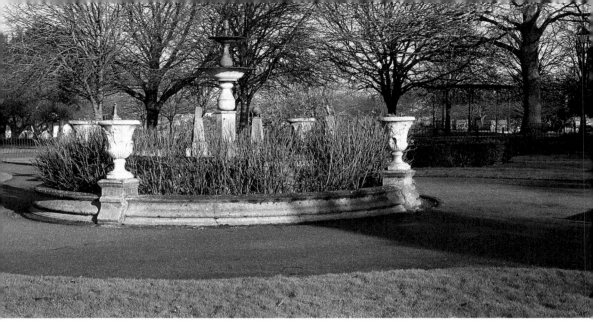

Above: The Sicilian Fountain Today

The original four classical statues have now been replaced by modern ones commemorating HMS *Beagle* (an unlikely looking Beagle!), HMS *Discovery*, HMS *Scylla* and HMS *Ark Royal*. The original bandstand seen in the background was dismantled in the 1950s and the current one, just visible among the trees, is virtually brand new having been a part of the park's restoration. (Author's collection)

Below: Devonport Park's Lower Lodge, 1910–30

Dating to 1858, this lodge was designed in the Swiss style made fashionable at the time by Prince Albert. Fore Street was then the main street in Devonport with shops and houses extending almost as far as this lodge. Built in 1876, the Great Western Railway Devonport and Stonehouse station was just along the road, now the site of City College Plymouth. It is amazing that the lovely ornate railings survived the calls for scrap metal during the Second World War. (Historic England Archive)

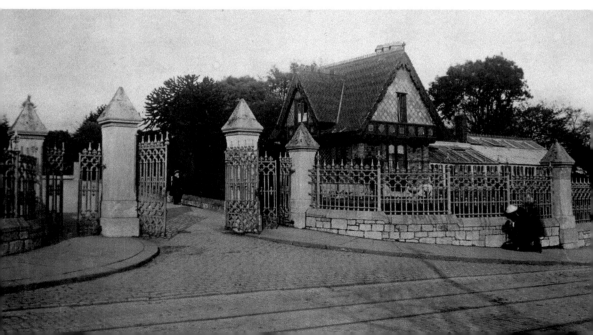

The text over the doorway reads:

> THE CARE OF THIS PARK
> MADE FOR THE USE OF ALL
> WITH PRIVATE AID AND
> PUBLIC FUNDS IS
> CONFIDED TO THE PEOPLE

> A D MDCCCLVIII R M WATSON MAYOR

The Lower Lodge Today
This current picture shows the details over the front door of the lodge, dated 1858. It never ceases to amaze me how much effort the Victorians put into decoration, even for a mundane building like a public park lodge. (Author's collection)

Mount Edgcumbe, 1973
A short ferry trip across the River Tamar is the lovely park, which used to belong to the Edgcumbe family but is now open to the public. It is also where I was brought up. This picture shows Mount Edgcumbe House from the main entrance soon after rebuilding finished in 1971. Originally built in the sixteenth century, it was burned out during the Blitz. The current house was rebuilt from 1958. (© Historic England Archive)

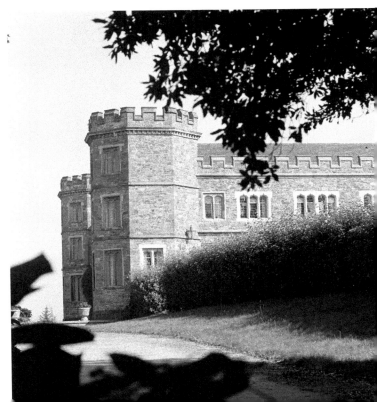

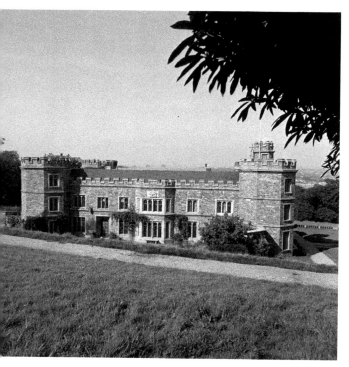

Mount Edgcumbe from the Rear, 1973

Although superbly rebuilt, the house we see today is smaller than the original. The original building with all its contents had been totally gutted in the Blitz so it was rebuilt under the supervision of Kenelm, the 6th Earl. Apart from losing his house, the Second World War also cost him his only son and heir, Piers, who was killed at Dunkirk. (© Historic England Archive)

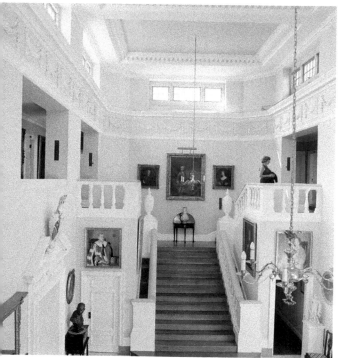

The Interior of Mount Edgcumbe House, 1973

As can be seen the interior has been beautifully finished in an eighteenth-century style. Finished in 1971, I can recall my mother, who had worked in the house at one time, being given a tour of the house along with most of the local people with contacts to the house. It has been open to the public since 1988. (© Historic England Archive)

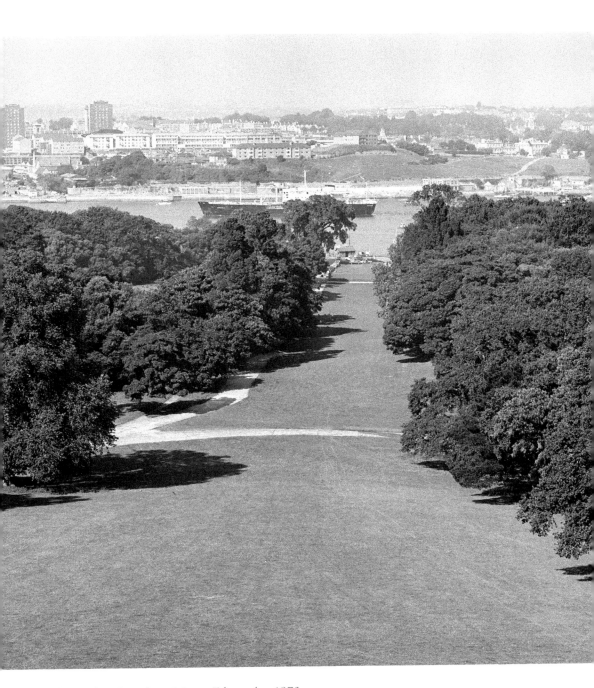

Plymouth as Seen from Mount Edgcumbe, 1973
This is the view from the front door of Mount Edgcumbe House, down the drive to Cremyll with Mount Wise in the background. Samuel Pepys visited in 1683 and described it as 'The most beautiful place as ever was seen' and few would argue with that. (© Historic England Archive)

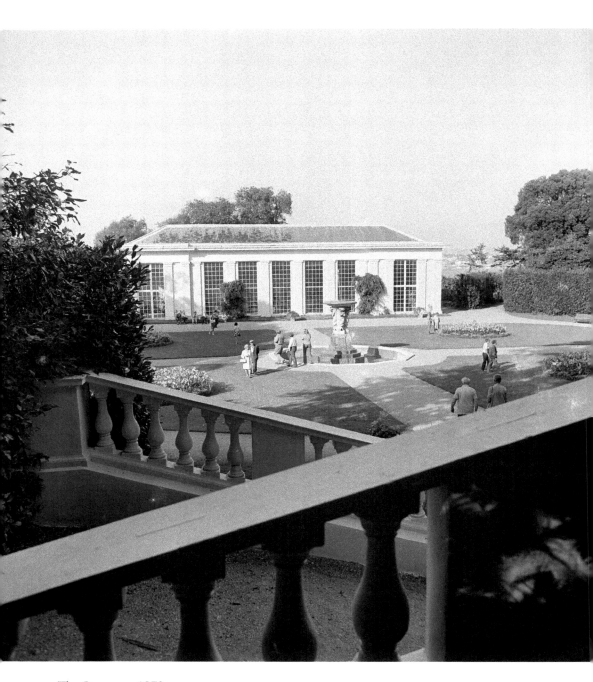

The Orangery, 1973
As you enter Mount Edgcumbe Park from Cremyll you will see the entrance to the formal gardens on your left. This Orangery was built in 1760 to allow 'the big house' to have fruit, with the trees being taken out in tubs and placed along the gravel walks during summer. In front of the Orangery is the Italian garden with its lovely mermaid fountain. (© Historic England Archive)

The Italian Garden, 1973
The opposite view from the previous one, from the Orangery across the Italian garden and mermaid fountain, showing the classical statuary and the stepped terrace, built some time before 1819. The Orangery sustained slight damage in the Blitz losing half its roof. It is now used as a café and wedding venue. (© Historic England Archive)

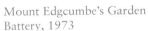

Mount Edgcumbe's Garden Battery, 1973
Like Drake's Island, this was another of the so-called Palmerston Follies designed to protect Plymouth from a French attack by sea or over land and built in 1863. It was designed to take seven 9-inch rifled muzzle-loader cannon located in casemates allowing a broad sweep of fire against any enemy ships. During Second World War it guarded a boom that blocked access to the Hamoaze. (© Historic England Archive)

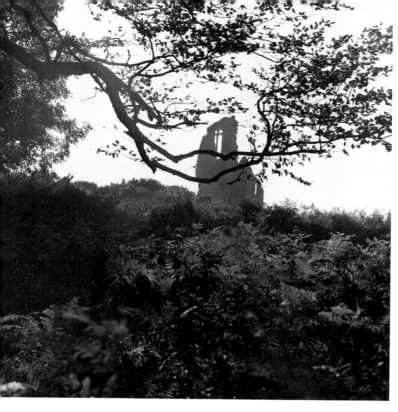

Mount Edgcumbe's Iconic Ruin, 1973
Built in the eighteenth century using stone salvaged from an old church in West Stonehouse (also at the time part of the Mount Edgcumbe estate), this folly occupies an area with the best views across the River Tamar towards Plymouth and Drake's Island and also the Sound and the Breakwater. (© Historic England Archive)

Freedom Park, 1900–05
Freedom Park doesn't look like this anymore: all the lovely flower beds have gone and it is now all grass. The terrace in the background is Queen's Gate, which still looks much the same, and the park does provide a place to relax in the centre of the city. (Historic England Archive)

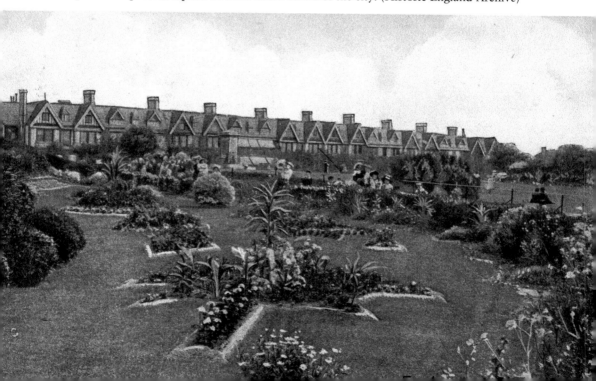

Drake's Island, 1973
In those days it was possible
to get access to Drake's Island,
either in your own boat or on a
pleasure boat, which took visitors
to the island. This happy band
had paddled or sailed across and
landed on the island where there
was, at the time, an adventure
centre, which operated until 1989.
The current owner's plans for
redevelopment include reinstating
public access. (© Historic England
Archive)

Drake's Island, 1973
Another view of a similar scene
but from the opposing viewpoint.
This shows a glimpse of some of
the fortifications and what I believe
was the old gatehouse, as well as
the old jetty, which – presumably
completely renewed – features in
the plans for the hotel that is to be
built there. (© Historic England
Archive)

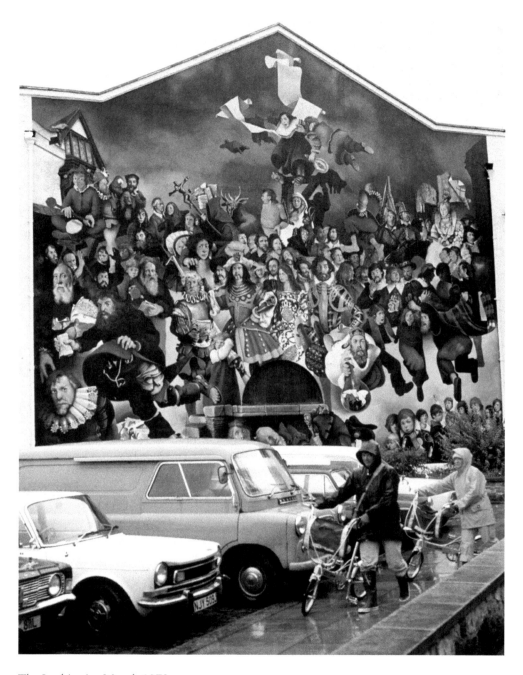

The Lenkiewicz Mural, 1873
Famous local artist Robert Lenkiewicz painted this mural in 1971–72. It was probably his best known and was certainly the largest, being painted on the complete back wall of a house. He died in 2002 and sadly this mural is now almost unrecognisable with faded paint and peeling plaster. (© Douglas Sargent and Graham Cooper's Art & Architecture (Historic England) Archive)

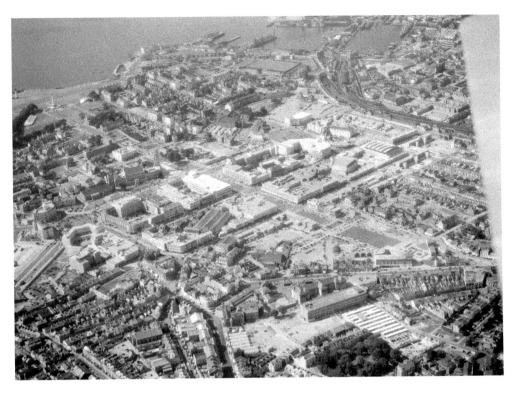

The City Centre, Hoe and Millbay, 1959

This aerial shot shows the new shopping centre with Armada Way stretching towards the Hoe and Millbay Docks top right. Below the docks is the old Millbay station, so here we have many holiday options, going away by train (which was the option for most Plymothians at the time), by ship or just strolling on the Hoe and seafront. (© Historic England Archive. Harold Wingham Collection)

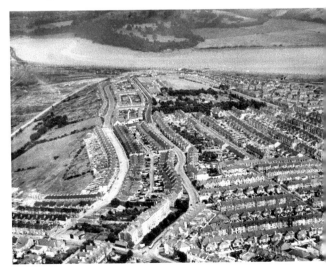

Mount Gould Showing the Laira and Saltram, 1937

This aerial shot shows Mount Gould in the foreground but with the Laira, the estuary of the River Plym, scene of many waterborne activities today including rowing, waterskiing and jet-ski riding, in the background. Beyond that is Saltram Park, now owned by the National Trust and a place where many Plymothians walk. (© Historic England Archive. Aerofilms Collection)

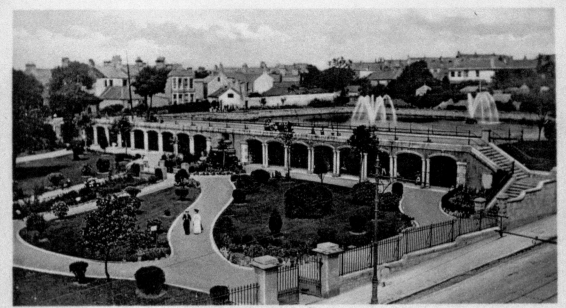

Plymouth, The Reservoir.

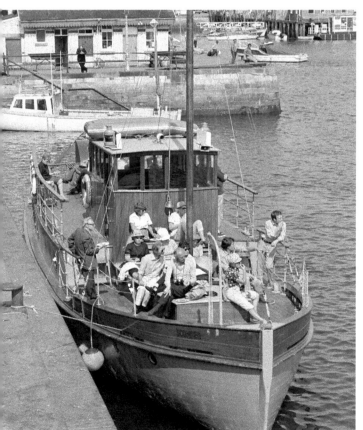

Above: Drake's Place Reservoir, 1900–30
Drake's Leat, built in 1592 by Sir Francis Drake, supplied Plymouth with water for centuries and ran through what is known as Drake's Place, which was the site of Drake's Mill, driven by the leat to grind corn for the town. In 1825 a reservoir was built there and this was Plymouth's main source of water until the 1970s. After restoration the site provided an oasis of calm in the centre of the city. (Historic England Archive)

Left: Boat Trip, 1973
As a maritime city Plymouth has never had a shortage of boats available and many an enterprising skipper has made a good living doing boat trips, whether for fishing, sightseeing (dockyard and warships being a favourite) or, in this case, birdwatching. The *Scomber* used to do birdwatching cruises along the Tamar, run by naturalist Tony Soper. (© Historic England Archive)

Sutton Harbour, 1973
This picture of Sutton Harbour shows a completely different one to the earlier one, taken in 1937. Already there are a great many privately owned pleasure craft tied up to the pontoons of the marina, and the numbers have increased by far more since. (© Historic England Archive)

Places of Worship

St John's Hall, Devonport, 1958

This was originally the Church of St John, Duke Street, a large and very plain building that has been described as looking more like a tithe barn than a church. It survived the Blitz but was used during and after the war as a community centre, surviving until 1958, so this was probably one of the last pictures before it was demolished. (Historic England Archive)

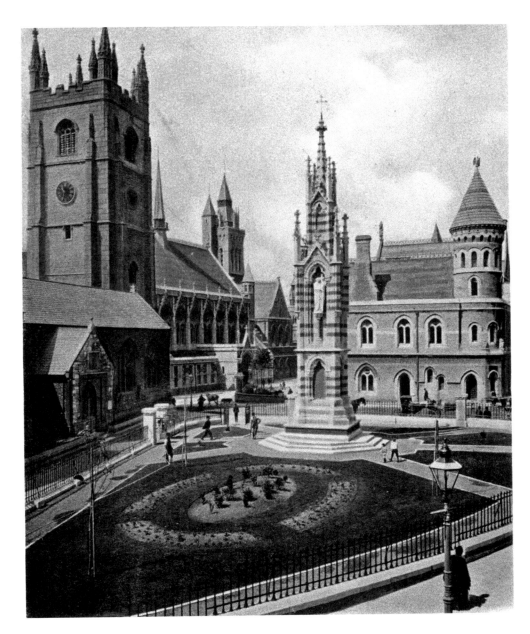

Another View of St Andrew's Cross 1900–20
The 70-foot-high St Andrew's Cross was built in memory of the local people whose graves were removed during road widening completed in 1895. Damaged in the Blitz, although still standing, it had to be dismantled and removed in 1941. The copper cross from the top can be seen inside the church and just outside the porch is a panel from the cross itself. (Historic England Archive)

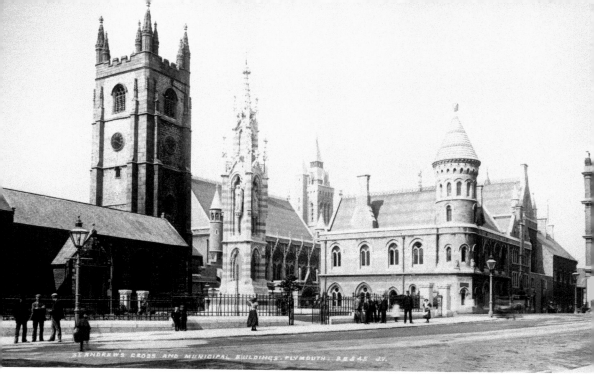

St Andrew's Cross, 1895–1920

There has been a church dedicated to St Andrew on this site since Saxon times but the present church looks much like it would have in 1500. Burned out in the Blitz, after which a board with 'RESURGAM' ('I will rise again') was fixed by the door, services were carried out within its walls in the open air until it was rebuilt in 1957. (Historic England Archive)

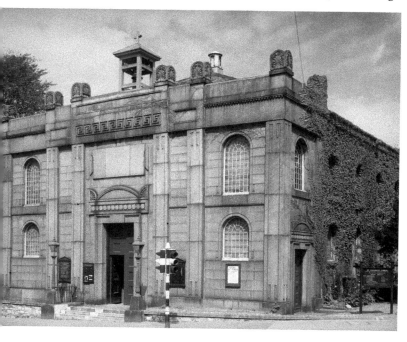

St Catherine's Church, Lockyer Street, 1943

Yet another Foulston building, St Catharine's stood across the road from the Theatre Royal Hotel in Lockyer Street. Opened in 1823, restored in 1879–80 and reroofed in 1912, it was a very plain stone box of a building, which had started its life as a chapel of ease for St Andrew's. It survived the Blitz but was bought by the council and demolished in 1958. (Historic England Archive)

Right: St Augustine's, Alexandra Road, 1994
Around the turn of the twentieth century the Emmanuel and Matthias churches could not cope with the expanding congregations so there was a need for another church. The site beside Alexandra Road was bought in 1898 and the church opened in 1900. Apart from having half the roof blown off by a bomb it survived the war, but was demolished in 2001 to make way for yet another block of student flats. (© Crown copyright. Historic England Archive)

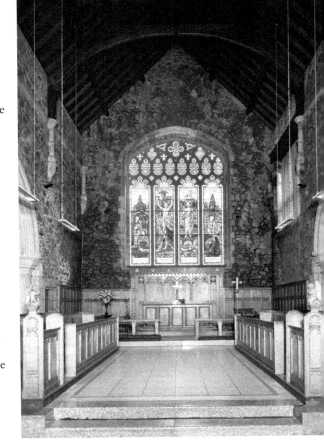

Below: Stoke Damerel Church Today
Dedicated to St Andrew with St Luke, the current church, on a site that has been a church since Saxon times, includes the fifteenth-century tower, but most of the building is eighteenth century and includes timber and components from ships donated by the Admiralty. Its out-of-the-way location at the time meant it was a creepy place at night and at least one murder took place there in 1788. Below the church on the shore of Stonehouse Creek (known as the Deadlake), in 1788, a double gibbet was erected to display the hanged bodies of two murderers. (Author's collection)

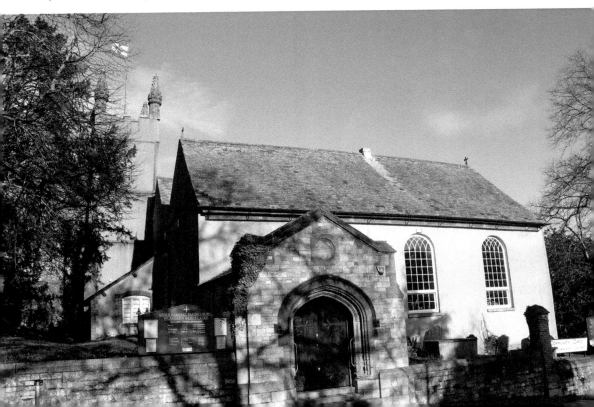

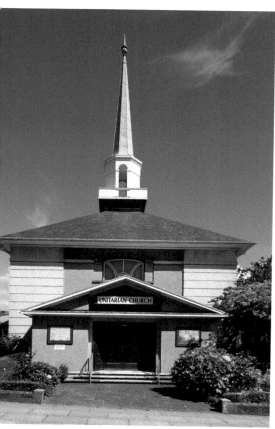

Above: Another View of Stoke Damerel Today
The original building was enlarged twice in the eighteenth century to the size we see today and then restored in 1868 and again in 1905. By 1871 the churchyard, seen here in the foreground, was full and smells were emanating from the rotting corpses, so a new Stoke Damerel burial ground was opened at Milehouse, near the bus depot, although that graveyard was also closed in 1967. (Author's collection)

Left: The Unitarian Church, Notte Street, 2013
There has been a Unitarian church in Plymouth since 1662, with previous church buildings being in Treville Street where a large, imposing building was erected in 1832 to replace an earlier one. This was destroyed in the Blitz and the building pictured opened in 1958. (© Historic England Archive)

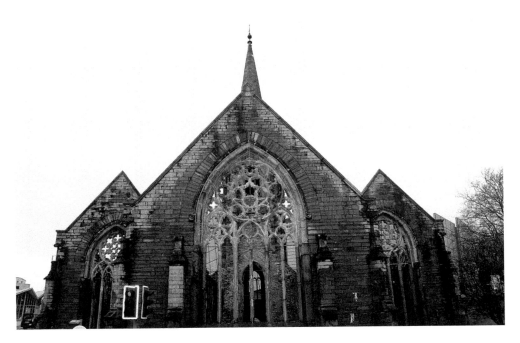

Above and below: Charles Church Today

The second oldest church in Plymouth after St Andrew's, Charles Church suffered the same fate in 1941 – being burned out – although the walls and steeple were undamaged. While it was decided to rebuild St Andrew's after the war, the decision was taken to preserve the ruined Charles Church as a monument to 'those citizens of Plymouth who were killed in air raids on the city', as the inscription on the commemorative plaque states. (Author's collection)

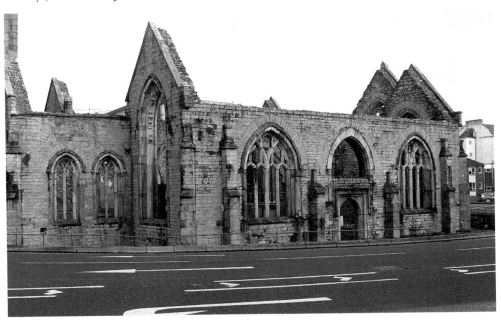

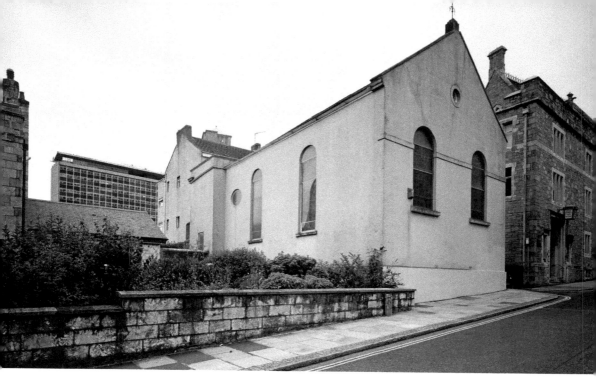

Plymouth Synagogue, 2002
Located in Catherine Street, near St Andrew's Church, this is the oldest Ashkenazi synagogue in regular use in the English-speaking world. Jews had settled in Plymouth since the mid-eighteenth century and this building was planned and the land leased in 1762 – although at that time a non-Jew had to hold the lease. The congregation bought the freehold from the city in 1834. (© Historic England Archive)

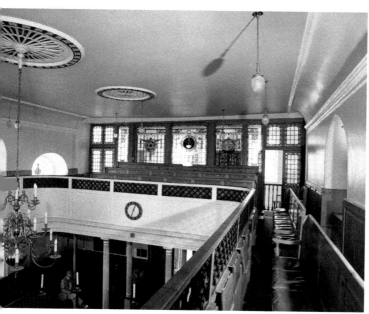

Interior View of the Synagogue, 2002
A uniquely beautiful building that is Grade ll* listed, this shows the lovely women's gallery and the rear windows. Much of the woodwork seen here was built to a superb standard by craftsmen from the dockyard. The joints in the woodwork are typical of shipbuilding techniques of the eighteenth century and show the skill and care taken by the builders. (© Historic England Archive)

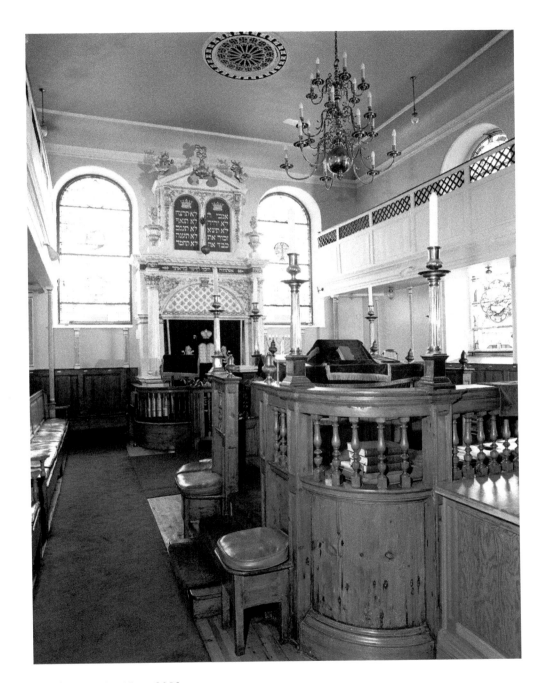

Another Interior View, 2002
This shows the beautifully built bimah, the platform from which services are conducted, and the baroque Dutch-built Ark, which bears the Hebrew date 5522 (dating it from the time the synagogue was built), has windows on either side, which were cut into the wall in 1874, and received their stained glass in the twentieth century. (© Historic England Archive)

About the Archive

Many of the images in this volume come from the Historic England Archive, which holds over 12 million photographs, drawings, plans and documents covering England's archaeology, architecture, social and local history.

The photographic collections include prints from the earliest days of photography to today's high-resolution digital images. Subjects range from Neolithic flint mines and medieval churches to art deco cinemas and 1980s shopping centres. The collection is a vivid record both of buildings that are still part of everyday life – places of work, leisure and worship – and those lost long ago, surviving only in fragile prints or glass-plate negatives.

Six million aerial photographs offer a unique and fascinating view of the transformation of England's towns, cities, coast and countryside from 1919 onwards. Highlights include the pioneering photography of Aerofilms, and the comprehensive survey of England captured by the RAF after the Second World War.

Plans, drawings and reports provide further context and reconstruction artworks bring archaeological sites and historic buildings to life.

The collections are housed in a purpose-built environmentally controlled store in Swindon, which provides the best conditions to preserve archive items for future generations to enjoy. You can search our catalogue online, see and buy copies of our images, as well as visiting our public search room by appointment.

Find out more about us at HistoricEngland.org.uk/Photos
email: archive@historicengland.org.uk
tel.: 01793 414600

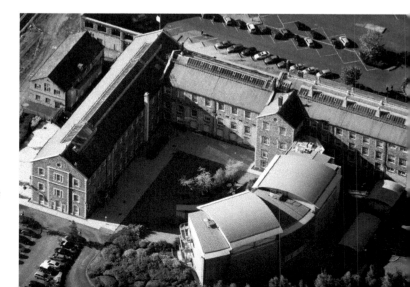

The Historic England offices and archive store in Swindon from the air, 2007.